IMAGES
of America

PUT-IN-BAY
THE CONSTRUCTION
OF PERRY'S MONUMENT

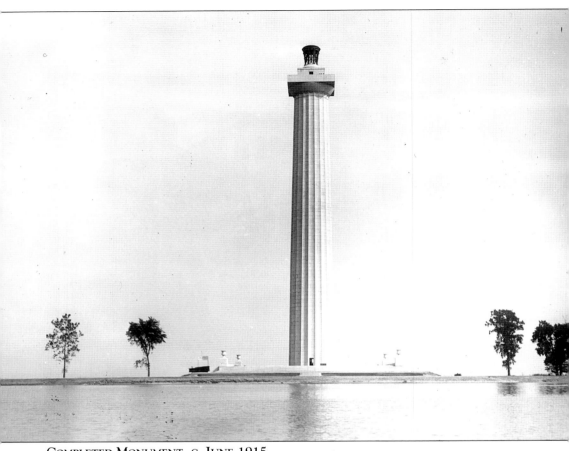

COMPLETED MONUMENT, C. JUNE 1915.

IMAGES
of *America*

PUT-IN-BAY
THE CONSTRUCTION
OF PERRY'S MONUMENT

Jeff Kissell

ARCADIA
PUBLISHING

Published by Arcadia Publishing
Charleston SC, Chicago IL, Portsmouth NH, San Francisco CA

Printed in the United States of America

Library of Congress Catalog Card Number: 2001092475

For all general information contact Arcadia Publishing at:
Telephone 843-853-2070
Fax 843-853-0044
E-mail sales@arcadiapublishing.com
For customer service and orders:
Toll-Free 1-888-313-2665

Visit us on the Internet at www.arcadiapublishing.com

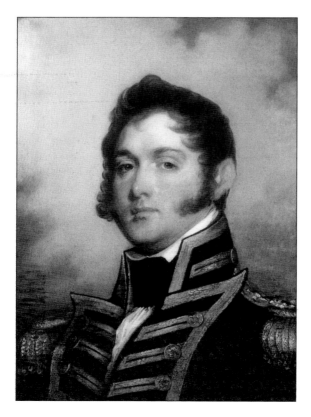

OLIVER HAZARD PERRY (I).

ACKNOWLEDGMENTS

Many people provided technical assistance and gave criticism that helped me to finally complete this work and reconfirm my lacking writing abilities. For their help and advice, I would like to thank the following individuals: Craig Whitmore, for spending many hours on guidance and ongoing reviews; Gerry Altoff, for eye-opening criticism; and Amy Newell, for taking time to advise. Other people whose help on this project I appreciate include: Phyllis Ewing, Ralph Moore, and Sue Judis, park curator, for authorizing the images I used.

I would also like to thank staff members and people who aided and provided information and photographs for this book.

Many gave me encouragement and enthusiasm, both ongoing and in passing, to continue this work, and I appreciate their words. There are also many others who helped in various ways, but they are too numerous to mention—for this, I apologize. I am simply glad to have had the opportunity to work on this project.

PICTURE CREDITS

BATTLE OF LAKE ERIE

"We have met the enemy and they are ours. . . ." So wrote Commodore Oliver Hazard Perry to General William Henry Harrison following his decisive victory over a British fleet at the Battle of Lake Erie. On September 10, 1813, Perry's squadron of nine vessels defeated and captured an English fleet of six vessels. The victory not only secured control of the best means of transportation into the expanding frontier, but served as a turning point in the War of 1812.

After the battle, American control of Lake Erie enabled unhindered troop movement to Canada, where General William Henry Harrison defeated a combined British, Canadian, and Native American force at the Battle of the Thames. Perry's victory served as a catalyst both for this battle and for ending hostilities in the Old Northwest Theater of the War of 1812.

During the remainder of his life, the country heralded Perry as a national hero whose bravery and fortitude enabled the United States to win, or gain an honorable peace from, its war with England. A deserving result of this victory was creation of a monument to honor Perry and his men. This book presents a pictorial and technical record of how a monument befitting this naval victory and the resulting peace became a reality.

ISLAND HISTORY

The earliest known inhabitants of South Bass Island (Put-in-Bay) were the indigenous peoples. They were known to island hop in order to canoe across Lake Erie. These Native Americans were also known to visit the island in the winter when ice conditions allowed crossing the lake to hunt raccoons.

There were some unidentified travelers who came to the island in July 1789. Charts were made of the island naming it "Pudding Bay" because of the shape of the harbor (of Put-in-Bay) resembling a pudding bag. It has also been recorded that the bottom of the harbor was soft like pudding, unlike the hard bottom of the rest of Lake Erie. British vessels of 1789 have notes referring to the harbor as "Puden Bay."

The earliest known white inhabitants of the island were French. In 1807, the Connecticut Land Company was formed in order to sell land in this area, known as the Western Reserve. In that same year, Pierepont Edwards acquired South Bass Island as part of an attempt to "equalize" the territory allotment he purchased, which was on an indented shoreline and not on a straight rectangle like other townships. An agent for Edwards, Mr. Suth Done came to the island and drove off the French squatters. After having brought laborers to the island to clear over 100 acres of land, he planted wheat and brought sheep and hogs to the island. After raising a spring wheat crop, his workers were busy threshing grain in the fall of 1812, when British soldiers drove them off the island and destroyed the crop. The following year, the British troops abandoned the island and in 1813, Oliver Hazard Perry made Put-in-Bay his base of operations.

Movement Toward
a New Monument

Homage to Perry's Victory at the Battle of Lake Erie demanded a monument of proportional size and significance. A lack of widespread concerted effort hindered its completion, although a few river mouth settlements on Lake Erie's shoreline raised modest statues honoring Perry. These settlements ultimately joined their state and national governments to erect, on South Bass Island, a monument more befitting to memorialize the battle. Prior to the Civil War, a variety of designs and locations including Middle Bass, South Bass, and Gibraltar Islands were proposed for building a monument honoring Perry. Each of these islands had something special, scenically and geographically, to offer as a site for a Perry monument.

Various landholders on Middle Bass offered tracts of land for a monument, particularly after 1900, when it appeared feasible on the island. Gibraltar Island, located in Put-in-Bay harbor and said to have figured importantly in pre-battle activities as Perry's lookout point for British ships, was considered. Civil War financier Jay Cooke, who later owned this island, dedicated himself to assisting in the creation of a monument to Perry. South Bass Island was the scene of an act that tipped the scale in its favor. Six officers killed in the battle from both navies were laid to rest on September 11, 1813, in a common grave on South Bass Island.

The first organized movement toward a monument began in 1852, which marked the approach of the 40th anniversary of the battle. On June 28, the *Sandusky Register* proposed the Fourth of July celebration at Put-in-Bay as the setting to organize a "Monumental Association" for construction of a monument. Reception of this movement toward a monument constructed on Gibraltar Island was enthusiastic. Colonel A.P. Edwards, a major landowner of Lake Erie Islands, offered the committee donations of land on Gibraltar and building supplies for construction. The Battle of Lake Erie Monument Association chose General Lewis Cass as its president. Cass had served as an officer in the War of 1812 under General Harrison and was later Secretary of War, Secretary of State, and a United States senator. The initial enthusiasm of this movement, however, dwindled and languished.

In July of 1858, the *Sandusky Register* again promoted construction of a monument, resulting in the formation of the Perry Monument Association. Once more, vigorous enthusiasm was reflected in the new owner of Gibraltar Island, Joseph de Rivera, restating a promise of land on Gibraltar for a monument. On September 10, 1859, at an anniversary celebration of the battle, an estimated crowd of 15,000 persons attended a cornerstone laying ceremony on Gibraltar Island. However, the setting of this cornerstone was this movement's greatest achievement.

In January of 1864, Jay Cooke, a nationally known financier of the Union cause during the Civil War, purchased Gibraltar Island from de Rivera for $3,001. When sold to Cooke, it came

subject to rights of any Perry Monument Association begun in or about 1859, to build with the laid cornerstone. Shortly after, Cooke erected upon the 1859 cornerstone a moderate memorial with a bronze tablet which reads:

"Erected by Jay Cooke—Patriotic Financier Of The Civil War—To Mark The Corner Stone Of A Proposed Monument Commemorating Commodore Perry's Victory At The Battle Of Lake Erie-Sept. 10, 1813 'We have met the enemy and they are ours.'"

Some feel Cooke's raising of this modest monument prevented any monument association from claiming rights on Gibraltar, since he could point out that a monument to Perry utilizing this cornerstone already existed on the island.

The idea for Perry's monument continued, and in 1868, at the 55th anniversary celebration held at Put-in-Bay, the Perry Monumental Association proposed a monument be built on South Bass Island at the burial site of the fallen officers of the battle. This movement, which suggested, "to build a hollow column, something like Bunker Hill Monument, with winding stairs. . . " never gained enough support to see its efforts brought to fruition.

Between 1890 and 1903, congressmen introduced 11 separate bills in the United States Congress for creation of a monument. All failed. The approaching 100th anniversary of the battle, along with the emergence of the natural abilities of one key individual, enabled a movement to succeed in erecting a memorial where past efforts had failed.

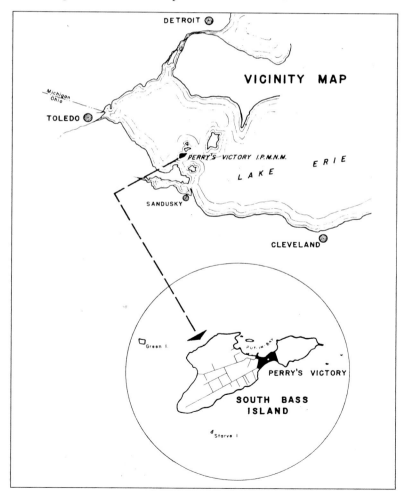

MAP OF ISLAND.

KEY PERSONALITIES
AND THEIR ROLES

A proposal made at a 1907 meeting of the Put-in-Bay Board of Trade (Chamber of Commerce) called for a grand centennial celebration on land and water to be held at Put-in-Bay from June to September of 1913. State and national government representatives were invited to participate along with locals in staging events for the celebration, with a monument to Perry at the center of this celebration. A committee was formed in June 1908, which received funds the following year through allocations by Ohio Governor Andrew L. Harris, enabling it to continue to raise funds for a monument. It was then that the key figure emerged that would be instrumental in the celebration project: Commissioner Webster P. Huntington.

Huntington descended from the founder of the Huntington National Bank of Columbus, Ohio, but broke family tradition by becoming a newspaperman instead of a banker. By using his natural influence along with keen business acumen, he gained the previously lacking financial support needed for construction of a monument to Perry. While on a lobbying visit to the Ohio legislature in January 1909, Huntington met a man familiar with the members of the legislature. He recruited John Eisenmann to aid in gaining support for construction of a monument, and his role in the construction proved to be second only to that of Huntington.

Eisenmann was a prominent architect and engineer from Cleveland as well as designer of the Ohio state flag adopted in 1902. Born in Detroit, he graduated as a civil engineer from the University of Michigan in 1871. He took an appointment with the U.S. Lake Survey, which maps waters and land masses in and around lakes. After gaining a position as chief of a division in 1874, Eisenmann earned a degree in architecture in 1877, from the Polytechnikum in Munich, Germany.

WEBSTER P. HUNTINGTON,
C. 1910.

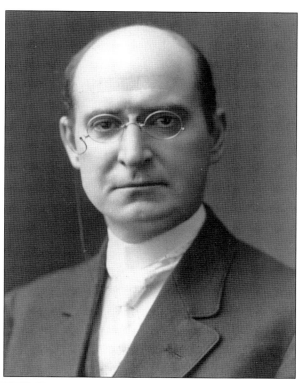

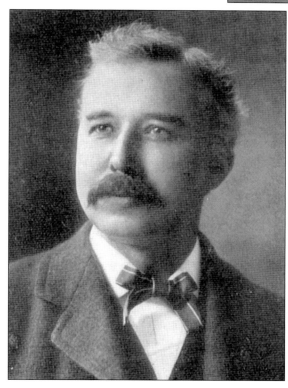

JOHN EISENMANN (II).

SUCCESSFUL MOVEMENT TOWARD CONSTRUCTION OF A MONUMENT

Huntington found architect and engineer Eisenmann, "perfectly familiar with the topography of Put-in-Bay Island and had made soundings of the surrounding waters and studied the geological formations of the region" (III). After he learned of the idea to build a memorial to Perry, Eisenmann became enamored with it and sketched his concept of a memorial design. After receiving encouragement from other members of the Perry's Victory Centennial Commission Board, Eisenmann gave his memorial concept substance by developing it into a large watercolor drawing This drawing aided Huntington in gaining support for the concept. Eisenmann's experience and familiarity with the islands also determined the location for construction when he suggested the "neck" joining the two lobes of South Bass Island.

Armed with his watercolor proposal, Huntington successfully lobbied the legislatures of those states which most benefited from Perry's victory: Ohio, Illinois, Michigan, New York, Pennsylvania, and Wisconsin. Kentucky also gave their support because a portion of the men in Perry's fleet consisted of Kentuckians from Harrison's army who volunteered for the duty. Perry's home state of Rhode Island also honored its hero and provided support, while Massachusetts later joined. As state governmental entities promised funds for the monument, they sent members to represent their interests to the Interstate Board of the Perry's Victory Centennial Commission. This cooperation enabled the commission to approach its financial goal of constructing a monument until the interstate team finally solicited the federal government for funding. Congress approved the appropriations, and President William Howard Taft signed them into law on March 3, 1911.

The additional federal appropriations allowed the commission to reach its goal, but these funds were conditional. Wishing to utilize the newly formed Commission of Fine Arts, Taft made funds available only if this new commission served as judge for a national contest to select a monument design. John Eisenmann's design was not utilized, but his recommended construction site on the isthmus of South Bass Island was. Despite this, Eisenmann gave his advice and guidance toward successful monument construction. Although paid $1,500 for his services, the monument became Eisenmann's personal enterprise rather than a pursuit for glory.

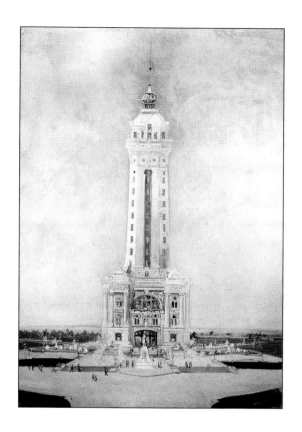

MONUMENT DESIGN CONTEST

In October of 1911, the building committee announced a "Program of a Competition" of the Interstate Board to come up with the most favorable design. Applying for admission to the contest were 147 architects and firms, from which 82 were selected. Presented at the National Museum in Washington, D.C. were 54 design exhibits, with their creators remaining anonymous to help insure impartiality. Prizes of $1,250; $1,000; and $750 were awarded to the final three competitors. George H. Worthington, the president-general of the Interstate Board of the Perry's Centennial Commission, announced Joseph H. Freedlander and Alexander D. Seymour Jr. of New York City the monument design winners. With the design chosen, architects prepared drafts of specifications. Consideration of construction bids for the massive Doric column began in May of 1912, and the following month, the building committee chose between the four submitted bids.

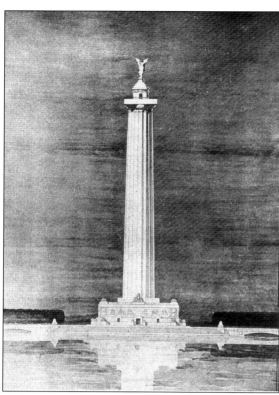

THIRD RUNNER UP (III).

SECOND RUNNER UP (III).

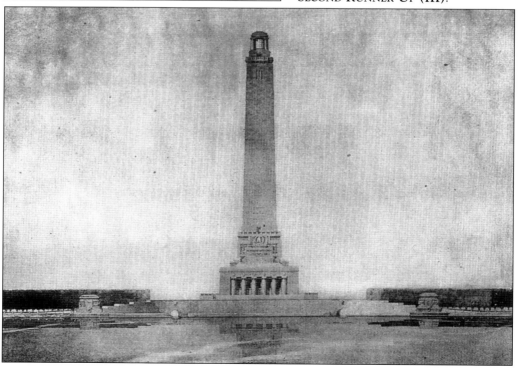

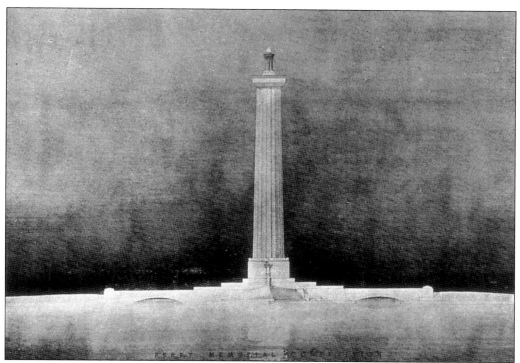

FIRST RUNNER UP (III).

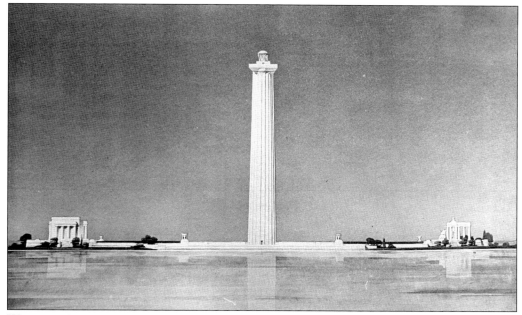

WINNING DRAWING, C. 1912.

JOSEPH H. FREEDLANDER. Photographer: David and Sanford, New York City, c. 1912.

ALEXANDER DUNCAN SEYMOUR (IV). Rare and Manuscript Collections, Cornell University Library.

CONSTRUCTION

John C. Robinson and Son General Contractors of New York and Chicago, submitted the winning bid for the monument construction, with their Chicago office performing the work. The bid was $329,851, but was later revised and raised to $358,588. All parties involved with construction signed the contract on September 10, 1912. Eisenmann's choice of the isthmus of South Bass Island would be the location for construction, so measures were taken to purchase or procure the desired pieces of land for building the monument.

Preparation of clearing the site was initially hired out to a Sandusky contractor named John H. Feick. His overly optimistic low bid (only two were submitted) of $850 was based on what he thought he could accomplish in a week to 10 days. After attempting to clear the site of trees and vegetation, it was obvious he had underbid the job, and after nearly three months of work, he received $1,808 for his efforts.

Although Feick cleared the site, it still looked as if it were "ravaged by a tornado." In many places the uneven ground required filling and leveling, while in other places standing water also required draining and filling. Upon inspection of the construction site, Roy L. Robinson, the 32-year-old son of the owner of the construction company and acting site manager stated, "Conditions on this island are much the same as those which confronted Robinson Crusoe" (VIII). The young Robinson rose to the challenge of these intimidating conditions and dealt with them piecemeal.

Initial erection of a 600-foot-long dock began in October 1912, because the shallow water of the harbor did not allow vessels to come up to shore near the construction site. Building a dock with rails and rail cars provided for the unloading of equipment, supplies, and granite (80,000 cubic feet) from barge to construction site. While the dock was being built, machinery such as the hoist machine, generating plant, and a boom (crane) power plant were hauled in and assembled, derricks assembled, storehouses erected, and the swamp filled in with cofferdams[1] built around the foundation site.

(opposite) SCENE LOOKING DOWN COUNTY ROAD NORTH OF THE MEMORIAL SITE BEFORE CLEARING BEGINS, C. OCTOBER 1911.

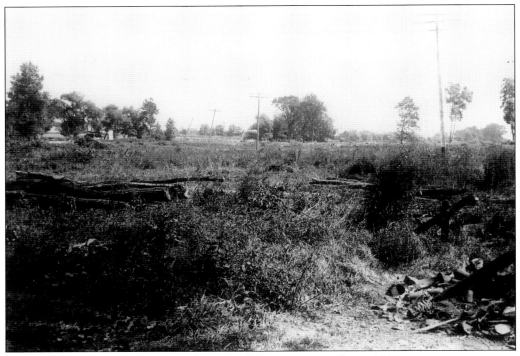

VIEW OF CENTENNIAL GROUNDS LOOKING NORTHEAST, C. JUNE 1912.

CENTENNIAL GROUNDS LOOKING NORTHEAST; BUILDING IS CONTRACTOR'S OFFICE, C. JUNE 1912.

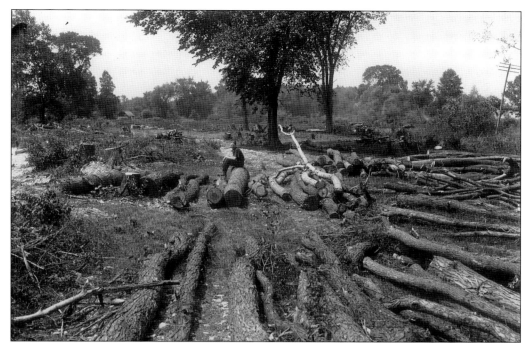

VIEW OF THE MONUMENT SITE FROM PRESENT DAY CHAPMAN AVENUE. The person on log is Harold Stork of Columbus, Ohio, a cousin of the photographer, *c*. June 1912.

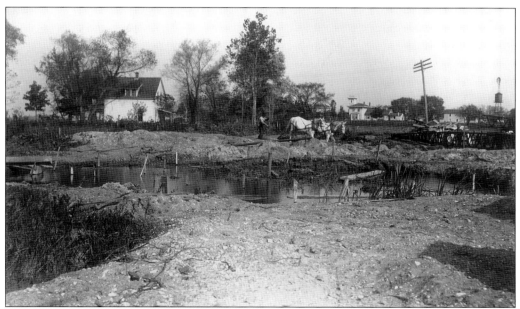

CLEARING GROUND FOR THE DIGGING OF THE FOUNDATION. Present site of memorial can be ascertained by the large post in the center of the small pool of water. A cofferdam was constructed, and the final drainage of pool was completed. The person driving the team is Leach, *c*. 1912.

PUMPING OUT THE SWAMP, C. 1912.

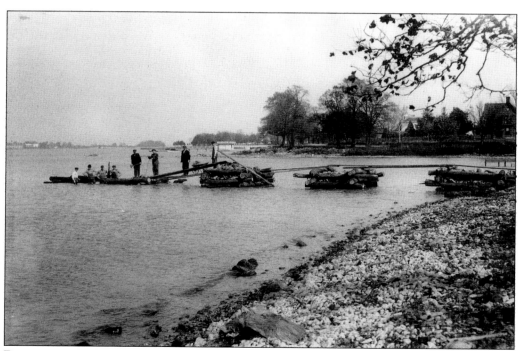

RAIL DOCK UNDER CONSTRUCTION, C. JUNE 1912.

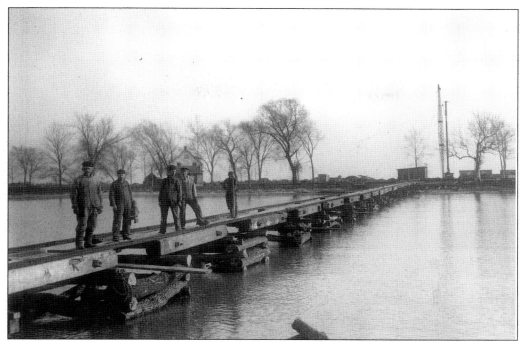

VIEW OF DOCK LOOKING SOUTH, NOVEMBER 29, 1912.

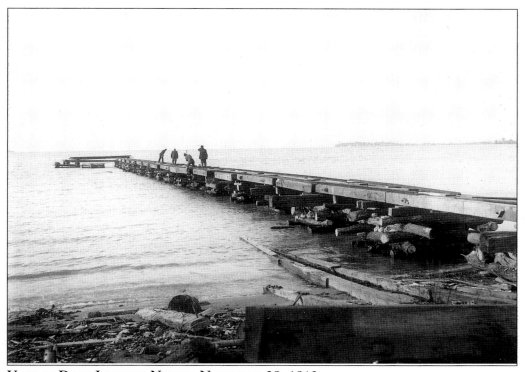

VIEW OF DOCK LOOKING NORTH, NOVEMBER 29, 1912.

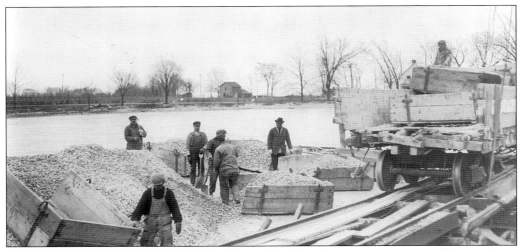

UNLOADING OF GRAVEL FROM THE RAILROAD CAR COMING FROM THE BARGE PIER;
LOOKING APPROXIMATELY SOUTHEAST, c. DECEMBER 1912.

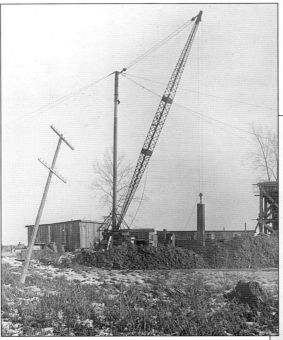

EXCAVATING FOR THE FOUNDATION.
The heavy square timber dropped from
the derrick arm was the method used
to find solid rock in the marshy swamp.
Just to left of hopper is the power shed,
and next to it is the construction shed,
December 26, 1912.

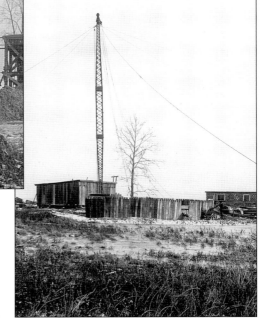

COMPLETED FENCE AROUND COFFERDAM
FOR EXCAVATION OF FOUNDATION. Note the
sheet piling; concrete hopper has not been
constructed in this photo, November 29, 1912.

Architect Versus Contractor

Excavation for the foundation began on December 4, and was completed 20 days later. The foundation was poured in a ring shape formed by pouring concrete between wooden forms placed inside steel sheet piling (cofferdam) and driven down to the underlying bedrock. The marshy soil made it necessary to use dry fill to support the inner circle of the forms. Dry fill was merely fill dirt brought from somewhere other than the actual construction site and used to support the forms. The building contractor took fill from an area around the construction site to use for supporting the forms. When architect Freedlander got word of this, he immediately sent notice to Robinson, stating that the contractor must supply all materials for constructing the memorial. Robinson now had to arrange to get his own sand, broken stone, or other fill for building.

The bedrock surface, though very smooth for concrete pouring, was about 3 to 4 feet below the core samples given to Robinson before the job. It was also on an incline, with a difference of about 3 feet from high point to low point. This resulted in cofferdams too low to keep water away from the construction. The architects instructed Robinson to "step off," or terrace the bedrock and clean it for foundation pouring, which meant making steps out of the slope to create a level surface for concrete pouring of a stable foundation.

Robinson performed this stepping of the stone and wanted to immediately pour the foundation during winter to avoid anticipated spring flooding. However, Freedlander sent notice to Robinson that any concrete put in during the severe winter would be condemned, requiring removal and delaying the construction. This delay was expensive, created problems in keeping the work crew together, and would require tending of the cofferdams. But because of inaccurate core samples given to Robinson, tending the cofferdams proved impossible: cofferdams could not keep out higher water since the bedrock was lower than anticipated.

A photograph in this book shows the pouring of concrete for the foundation on December 26, 1912, indicating that Robinson did indeed proceed with setting the lower portion of the foundation in hopes it would survive the winter intact. Unless the picture was dated incorrectly, Robinson proceeded with winter pouring, and it solidified well. Spring flooding occurred, requiring some of the work to be done again, but no record of demolition of the foundation exists. By June, the site drained enough to allow for pouring the upper foundation.

For the upper foundation, wooden forms continued the ring shape another 10 feet above ground level. The surface of the entire finished foundation rises approximately 22 feet above bedrock. Late in June of 1913, the granite blocks (which started arriving earlier in the year) sat ready to be used for monument construction. However, breakdowns of equipment, like the electric generator which caught fire and burned, caused delays in setting granite blocks. Freedlander then sent critical letters to Robinson, pointing out what he perceived as defective machinery and a lack of manpower. He also felt that those granite blocks already delivered

and stacked around the construction site got in the way of the work, indicating to him a lack of organization. He repeatedly requested that Robinson remedy these problems at once, but Robinson had a grasp of the situation. These disputes set a strained tone for the professional relationship between architect and contractor.

The dispute over the foundation work delay and the resulting work pay disagreement resulted in Robinson filing for arbitration over the matter. Various issues arose that Freedlander found not up to his standards because Robinson's problem solving techniques were not as Freedlander would handle them. A record of correspondence between contractor Robinson and architect Freedlander is preserved in the archival collection of Perry's Victory and International Peace Memorial.

Personal conflicts that formed during this project add an emotional and riveting side to the construction. Differences in personalities and construction methods culminated in making the monument what it is today. Although Freedlander appears as an irritant to Robinson, his ongoing scrutiny resulted in a finished monument that will continue to stand the test of time.

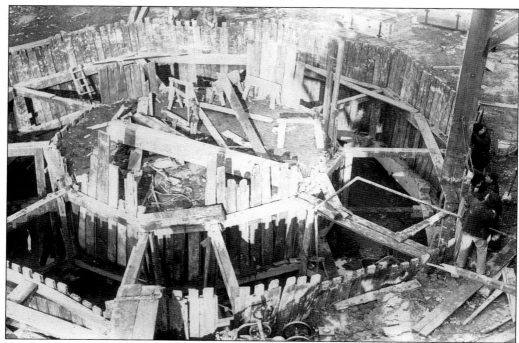

COMPLETED FORMS FOR POURING OF THE CONCRETE FOUNDATION. Some of the work being done here includes repairs of winter storm damage. Earth was left in the center to support the interior forms. At this point in construction, a square beam would be dropped by the derrick to drive the sheet piling into place, December 26, 1912.

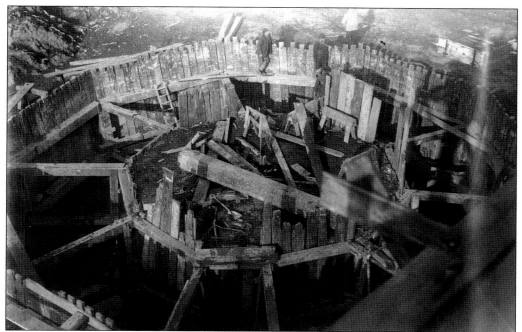

Foundation Under Construction, December 26, 1912.

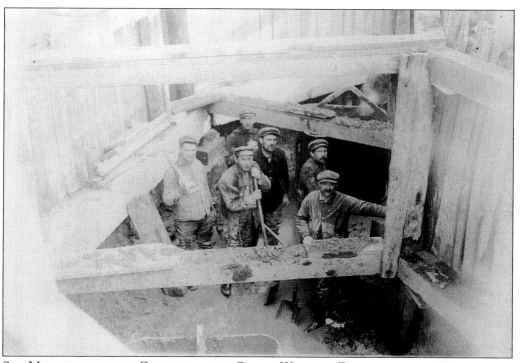

Six Members of the Construction Crew; Wooden Forms for the Pouring of Concrete. The large bucket in lower center of photo was used for handling the heavy equipment, December 26, 1912.-

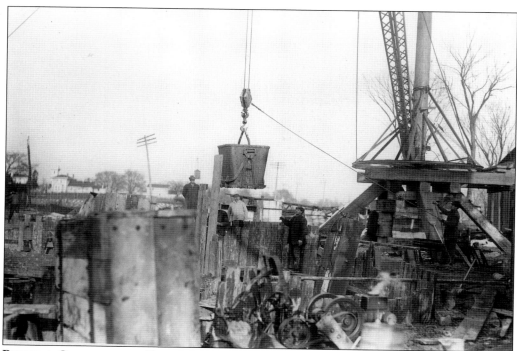

POURING CONCRETE FOR FOUNDATION, DECEMBER 26, 1912.

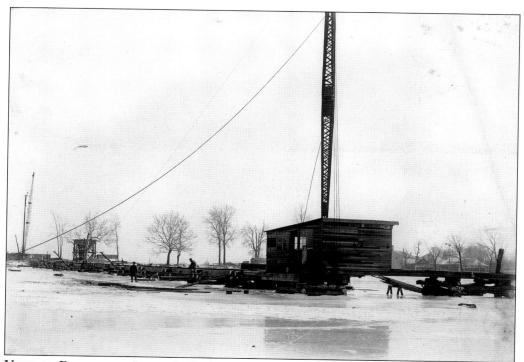

VIEW OF DOCK FROM LAKE. Cofferdam and most excavation was completed by the winter freeze. During this period, work was done on the dock, tower, and crane, c. January 1913.

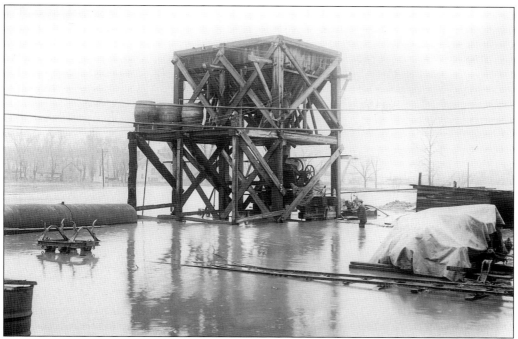

VIEW OF THE EXCAVATION SITE. The small gauge railroad was used to move heavy equipment. Hip-deep in water is photographer G.O. Herbster. The building on the far right is a construction shed, April 10, 1913. Photographer: Mark Gunn.

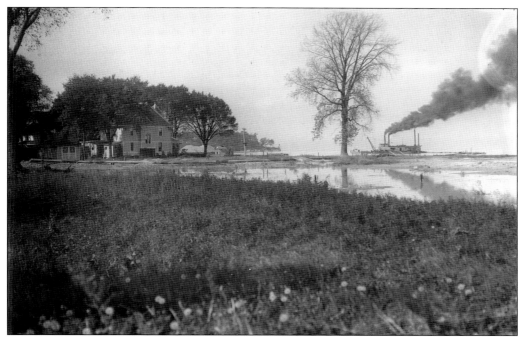

STEAM BARGE IN BAY, JUNE 17, 1913.

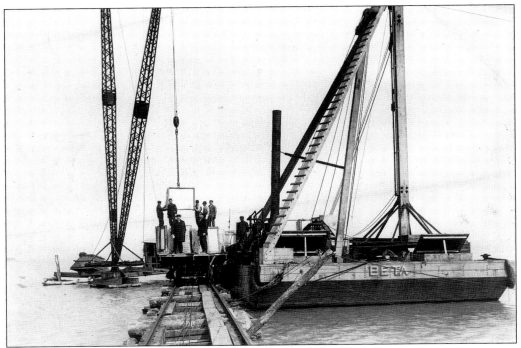

LAKE END OF DOCK SHOWING THE CONVEYANCE OF GRANITE BLOCKS FROM BARGE TO FLATCAR FOR TRANSFERENCE TO MEMORIAL SITE. The *Beta* was owned and operated by the Freyense Bros. of Sandusky, Ohio (tug *Grandon* also owned by Freyense Bros.), and the dock derrick was operated by steam electric generator on the construction site. The cables were used for moving blocks and other material. Every block was crated to fit in with the overall plan and cut to measurement at the quarry, *c.* April 1913.

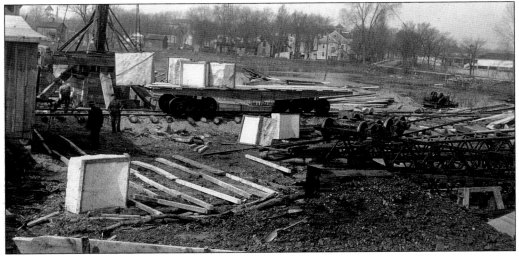

UNLOADING OF GRANITE BLOCKS FROM FLAT CARS WHERE THEY WERE TRANSFERRED TO THE SITE FOR STORAGE AND USE. The person facing derrick is Henry Bell, *c.* March 1913.

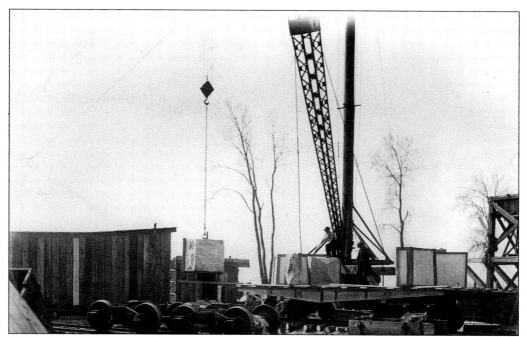

HANDLING OF GRANITE BLOCKS STACKED AT SITE; FOUNDATION JUST TO RIGHT OF PHOTO. Looking from the foundation at the derrick would be almost due south, *c.* April 1913.

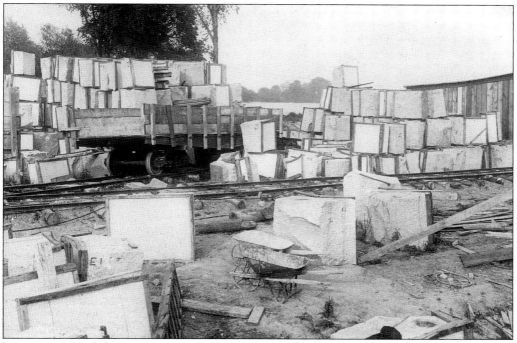

UNLOADING AND STACKING OF GRANITE BLOCKS. The construction shed is on the right, and the hopper would be just to right of the shed. Marks on the granite determine its location in the monument, June 17, 1913.

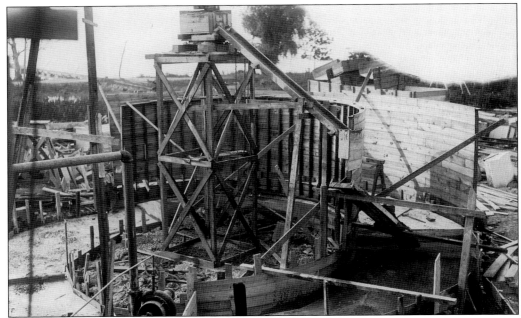

SETTING UP FORMS FOR POURING THE FOUNDATION. In lower left is the electric motor, which later burned up. After pouring the center, the frame was located and gouged out to enable concrete to be raised as the construction progressed. Pumps were used to extract water as the concrete was poured, June 17, 1913.

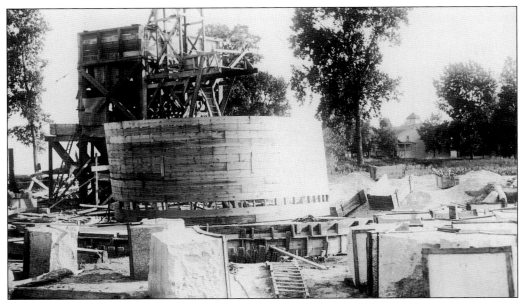

SHOWING COFFERDAM AND FORMS FOR POURING CONCRETE FOUNDATION OF MEMORIAL COLUMN. (The setting of forms for the second major course of concrete was poured from ground level up to level where granite setting would begin.) Below this level, approximately 12 feet of concrete had been poured, and from ground level to top of the form would be approximately another 10 feet, c. June 1913.

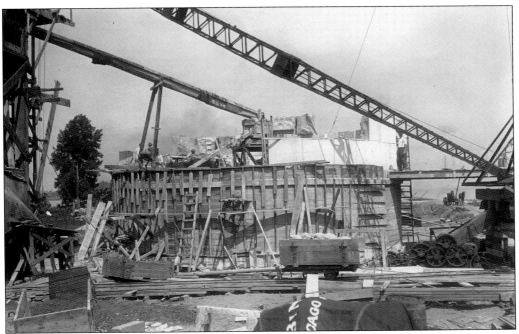

POURING CONCRETE INTO FOUNDATION FORMS; TARPAULIN IS BEARING NAME OF ROBINSON, CHICAGO, JULY 2, 1913.

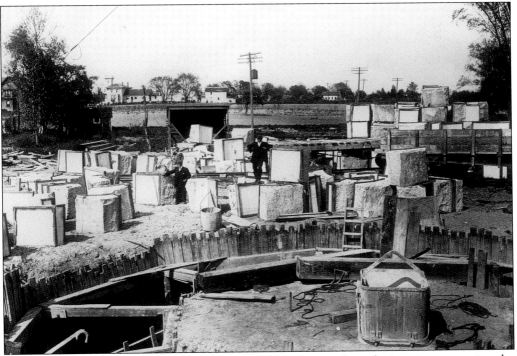

WORK CONTINUING ON FOUNDATION. Loads of blocks were brought in prior to pouring the foundation, which had to be done in one continuous operation, April 12, 1913.

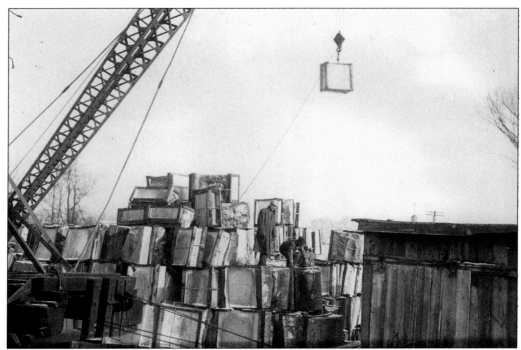

GRANITE BLOCKS BEING STACKED. The cables in the lower left-hand corner supplied power to the railroad cars. The person standing is Roy Robinson, February 1913.

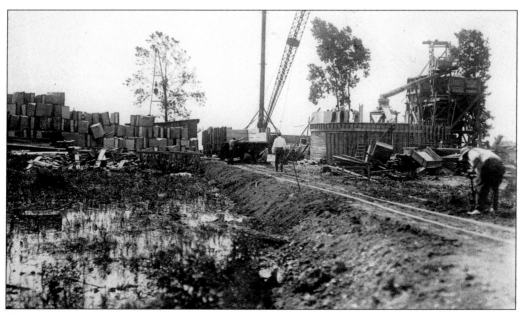

FOUNDATION CONSTRUCTION OF FIRST COURSE OF GRANITE. Walking away from the camera is Roy Robinson, contractor.

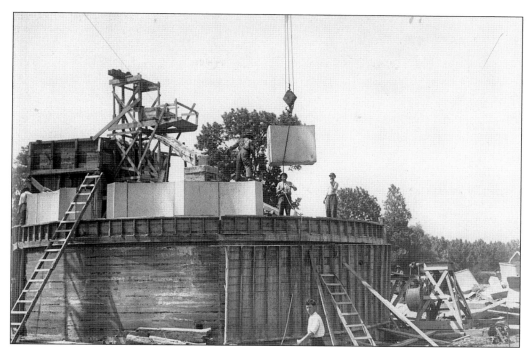

LAYING OF THE FIRST COURSE OF GRANITE BLOCKS ATOP THE CONCRETE FOUNDATION. On the platform right in derby is Henry Bell, Robinson's foreman, always wore a derby, June 27, 1913.

BURNT OUT ELECTRIC MOTOR DURING CONSTRUCTION. It was the cause of legal arbitration, c. 1913.

ENGINE ROOM FIRE RUINS, NO DATE.

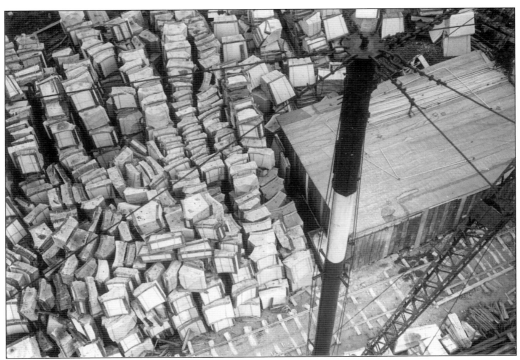

LOOKING DOWN ON MAZE OF GRANITE BLOCKS, NO DATE.

CEREMONIES

The first layer or course of granite blocks was set in preparation of a formal cornerstone laying ceremony scheduled for July 4, 1913. This ceremony climaxed with Interstate Commission Secretary General Webster P. Huntington placing documents relating to the memorial and the centennial celebration, as well as Masonic papers, in a steel strongbox that was then placed inside the cornerstone.

On September 11, another ceremony of the centennial celebration took place for the re-burial of the six officers, three British and three American, who lost their lives in the battle. The American officers re-interred in the ceremony were Marine Lieutenant John Brooks, Midshipman Henry Laub, and Midshipman John Clark, along with British officers Captain Robert Finnis, Lieutenant John Garland, and Lieutenant James Garden. After the battle, September 11, 1813, these officers were buried in a common grave located in what became DeRivera Park. One hundred years after their burial, their remains were disinterred and reverently entombed under the floor of the rotunda in the monument. Both of these centennial ceremonies were Masonic (Freemason), providing much pomp and circumstance.

The work completed between the cornerstone and interment ceremonies was critical. It consisted of forming the dome of the rotunda, except for the center of the ceiling and floor, as well as setting the fourth through eighth courses of granite. Pouring the foundation of the column as a hollow concrete cylinder facilitated later construction. A hole made in the northwest point of the foundation allowed a chute to angle down from the concrete mixing hopper outside toward the foundation center. Inside the foundation, concrete poured into this chute emptied into a large bucket, which was then lifted to the level of need in construction. Because of this, the center of neither the floor nor the dome of the rotunda could be finished, neither could the permanent elevator shaft be installed until the need for concrete at higher levels ended.

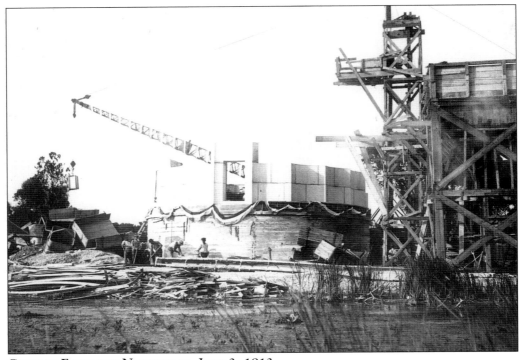

COLUMN FROM THE NORTHEAST, JULY 3, 1913.

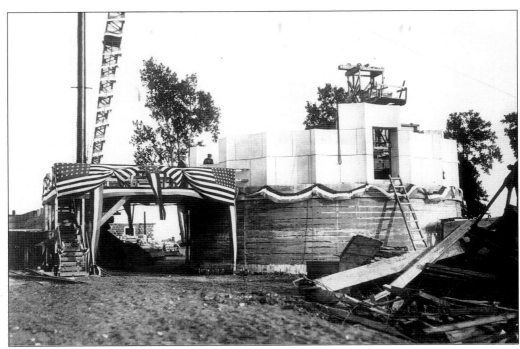

PREPARATION OF FOUNDATION FOR CORNERSTONE-LAYING CEREMONY; ROBINSON IS ON THE BALCONY, JULY 3, 1913.

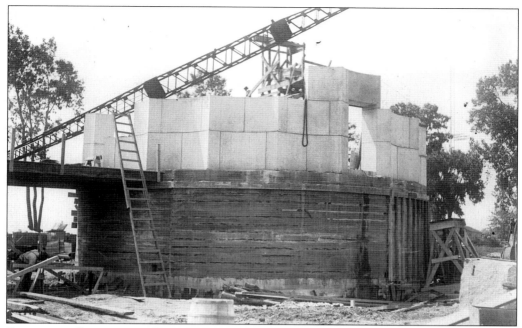

SETTING OF SECOND AND THIRD COURSE OF BLOCKS PRIOR TO LAYING OF CORNERSTONE. To the right of form is the stand, or heavy scaffolding, that was used the preceding year to start the sheet piling before bringing in the heavy power beam. To the left of foundation is platform used for cornerstone-laying ceremony; cornerstone of northeast entrance to monument, July 3, 1913.

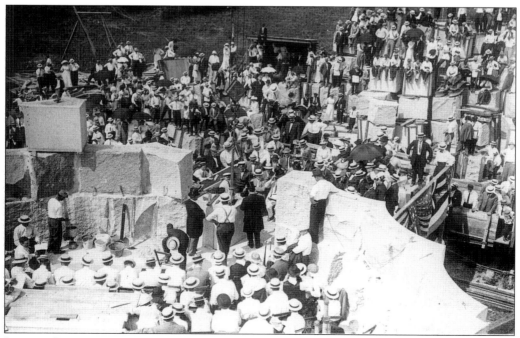

LAYING CORNERSTONE, JULY 4, 1913.

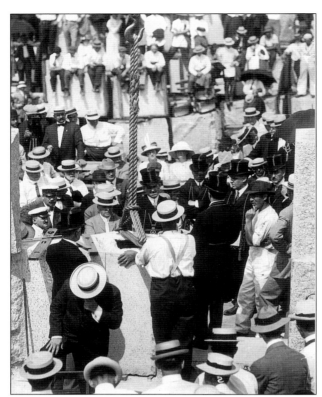

CORNERSTONE-LAYING CEREMONY. Photographer: E.H. Schlessman, Sandusky, Ohio, July 4, 1913.

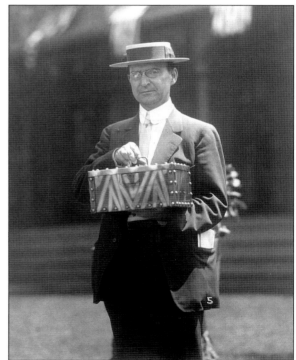

WEBSTER P. HUNTINGTON HOLDING STRONGBOX THAT WAS LAID INTO CORNERSTONE OF MEMORIAL, NEXT TO EAST DOORWAY, JULY 4, 1913.

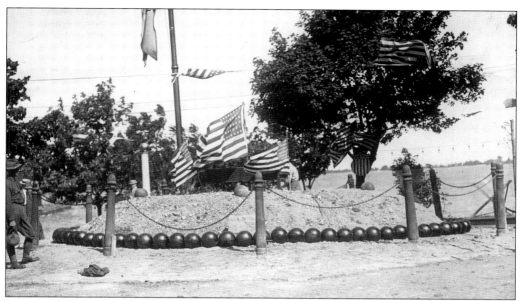

ORIGINAL BURIAL SITE OF OFFICERS KILLED IN THE BATTLE OF LAKE ERIE, c. SEPTEMBER 1913.

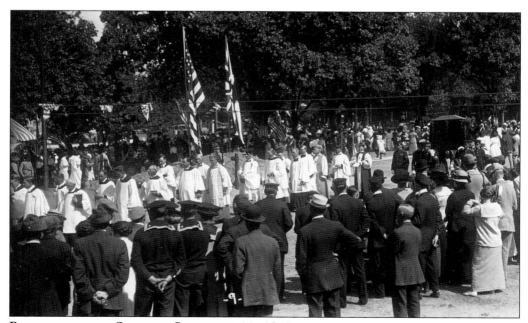

RE-INTERMENT OF OFFICERS, SEPTEMBER 11, 1913.

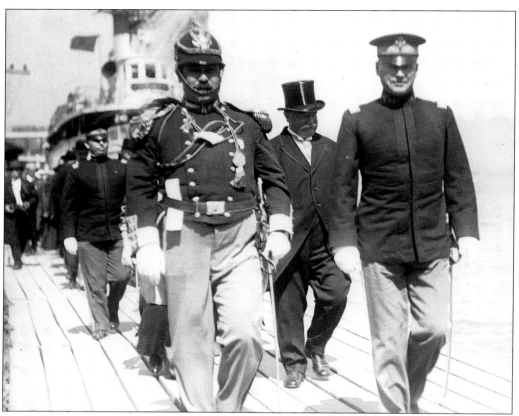

CENTENNIAL CEREMONIES. Former president Taft is in center wearing tall hat, September 11, 1913.

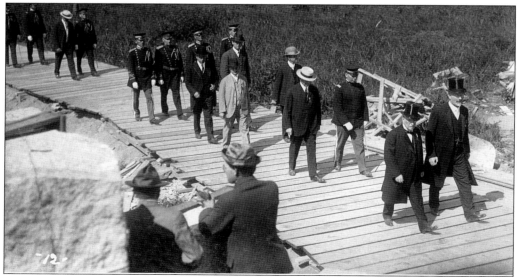

PROCESSION OF DIGNITARIES AND HONOR GUARD TO THE COLUMN WHERE OFFICERS WERE RE-INTERRED, SEPTEMBER 11, 1913.

PROCESSION CARRYING REMAINS OF OFFICERS TO BE RE-INTERRED IN MEMORIAL CRYPT, SEPTEMBER 11, 1913.

BEARING THE CATAFALQUE UP THE STAIRS INTO THE ROTUNDA, SEPTEMBER 11, 1913.

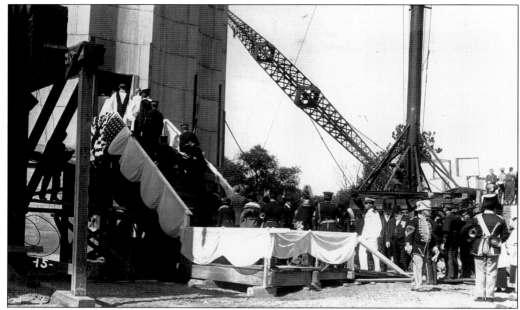

BEARING THE CATAFALQUE UP THE STAIRS INTO THE MEMORIAL, SEPTEMBER 11, 1913.

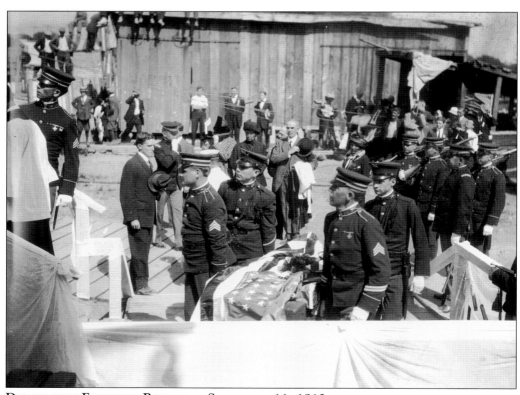

DIGNITARIES ENTERING ROTUNDA, SEPTEMBER 11, 1913.

SPECIAL TECHNIQUES INSIDE

In a 1972 recorded interview, Mr. James Hodgson, a worker on the project, stated that the rotunda was one of the most difficult parts of the construction. The work necessary in building the rotunda limestone wall facing, the spiral stairways between rotunda and granite, the domed ceiling, and the four horizontal reinforced-concrete girders supporting the staircase around the elevator shaft above the dome made this section crucial. The concrete backing the column's exterior granite as well as the rotunda face limestone was poured in stages (layers) after setting. Forms set between the respective granite and limestone facings created the spiral stairways with the thin stonework of the dome laid on centering (frames) and keyed (held) with dovetail extrusions held by the concrete backing.

The rotunda ceiling stands about 20-feet high and slightly less in diameter than the monument well, which rises above the rotunda at a uniform 27 feet 6 inches. The domed ceiling, carved from Bedford (Indiana) limestone and backed with concrete, is faced in decorative panels of this limestone, which also covers the rotunda walls. Two spiral stairways formed in the wall around the rotunda ascend to a reinforced-concrete floor a few feet above the domed ceiling. "Essentially the rotunda resembles the upper half of an eggshell set inside a cylinder made of the rings of granite ashlar[2] blocks. The space in between consists of poured concrete through which the two spiral staircases rise" (IX). Workers set the ends of four steel reinforced concrete girders inside this concrete filler, below the bottom landing floor, and above the rotunda dome. These girders support the four, 16-inch octagonal columns, which are set in a 13-foot square and rise the entire height in the center of the column to support the main central staircase and a 7-foot square elevator shaft (see diagram A.).

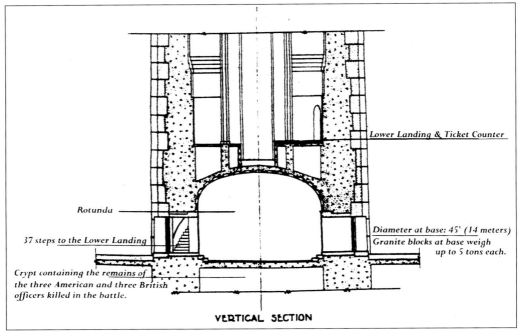

Lower Landing & Ticket Counter

Rotunda

37 steps to the Lower Landing

Crypt containing the remains of
the three American and three British
officers killed in the battle.

Diameter at base: 45' (14 meters)
Granite blocks at base weigh
up to 5 tons each.

VERTICAL SECTION

DIAGRAM A.

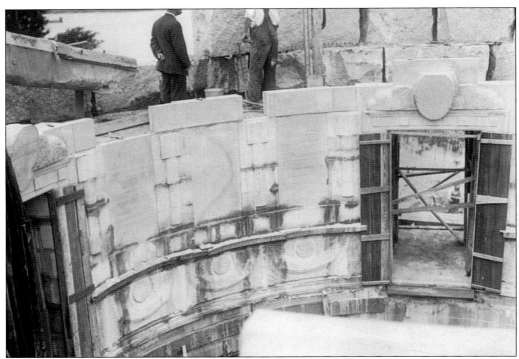

VIEW OF ROTUNDA WALL DURING WORK ON FOURTH COURSE OF GRANITE, July 16, 1913.

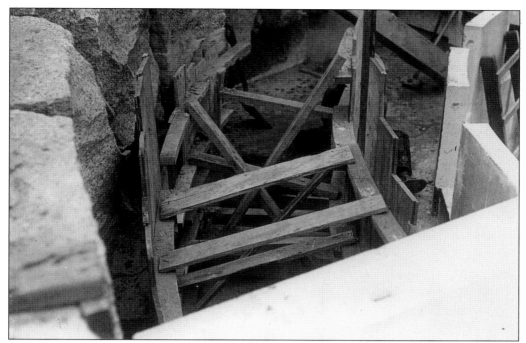

INTERIOR OF COLUMN WITH A VIEW OF THE FORMS USED TO CREATE STAIRWELLS. Decorative limestone panel to right, July 16, 1913.

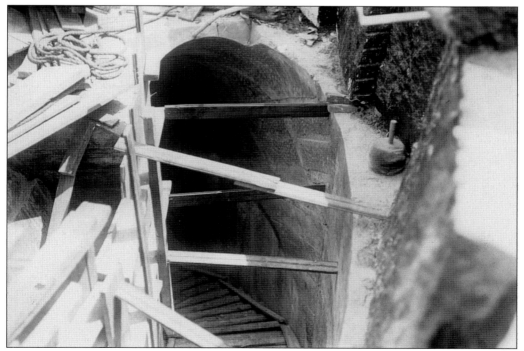

VIEW OF STAIRWAY; MALLET TO RIGHT OF STAIRWAY WAS USED FOR CARVING BY STONE CARVERS, AUGUST 5, 1913.

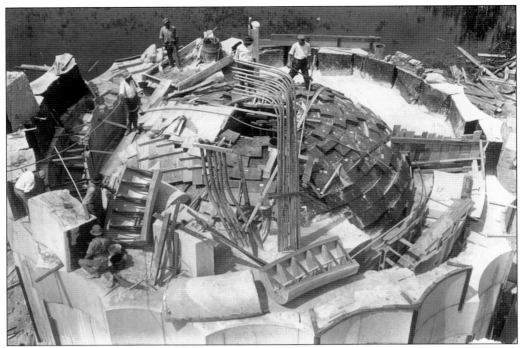

EXPOSED DOME OF ROTUNDA; FORMS ARE FOR STAIRWAYS, SEPTEMBER 15, 1913.

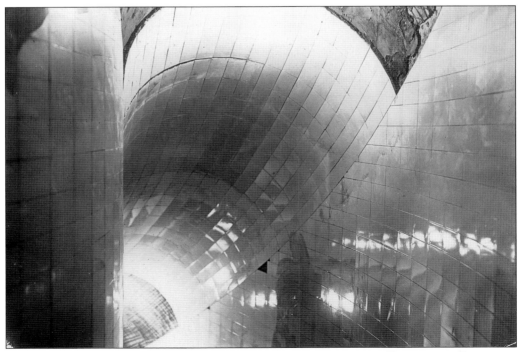

VIEW OF TILES IN STAIRWAY BETWEEN ROTUNDA AND ELEVATOR LANDING, C. SEPTEMBER 1914.

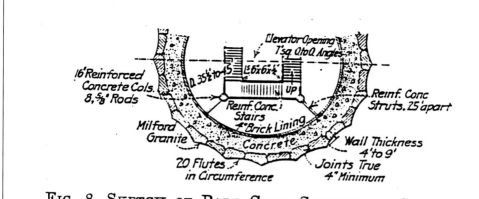

FIG. 8. SKETCH OF PART CROSS-SECTION OF SHAFT OF PERRY MEMORIAL

PART CROSS SECTION OF SHAFT.

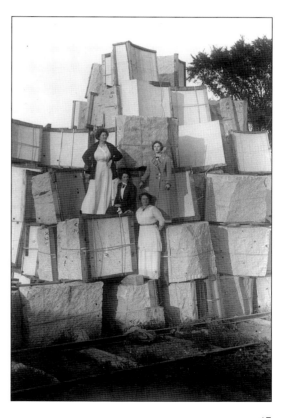

STACKS OF BLOCKS. Numbers and wood frames can be seen.

MONUMENT EXTERIOR

Monument Exterio

The shaft of the column is 45 feet in diameter at the base and tapers to 35 feet 6 inches at the throat, just under a square cap measuring 47 feet 6 inches on each side. Due to this taper, each of the granite blocks has a particular batter[3] with only one location where it can fit within the column. To achieve this, the builders plumbed the blocks and set the batter of each block true to the faces of the block below. They checked the diameter of every two courses, and any variation from planned dimensions was corrected in the next course setting.

The granite selected by Robinson was Milford Pink Granite. The plan was for the monument to appear white; however, the natural tendency of pure white stones is to take on a bluish cast of a clear blue sky. The pink tone of the Milford Pink Granite counters this tendency and helps the structure stand out at a distance. Thirty blocks of three basic shapes comprise each course and create the flutes of the column.

The blocks are essentially rectangular with three variations. One has a flat rectangular face, the second a rectangular face flaring toward you on the right side, and the third, with a left side face flaring toward the observer. These three shapes of blocks create two flutes with 30 blocks per course, making the 20 flutes of the column. By shifting the ring of the course one block in either direction, the anchoring bond of every other block makes the next course above and below deeper, alternating the header[4] and stretcher[5] settings. This means that one block would be shallow from its face toward the rear, and the next one would run deeper, followed by another shallow, and so on. Alternating the deep and shallow blocks made a stronger finished structure. The next course of blocks is set the same way, but is offset by one block from the course below and above, making each deep block with a shallow one above and below it. This alternation continues to the top.

The granite is backed and anchored in concrete. The anchors consist of a piece of preformed one-quarter-inch steel bar stock (common steel bar) about 1.5 feet long by 1.5 inches wide, running down from a hole in the top of the granite backward and held by the poured concrete backing. This backing created a circular well 27 feet 6 inches in diameter throughout the height of the monument above the rotunda.

HANDLING MATERIAL

The blocks, mined, cut, and numbered at the Milford Quarry located in Milford, Massachusetts, had edges and corners vulnerable to breaking and chipping. This required crating each block in wooden framing for protection during transportation. With each piece of granite hoisted to its spot in the construction, the wooden framing was removed and discarded. Each block had one or two holes cut in its top toward the rear about 2.5 inches deep by about 3 inches long and about half an inch wide. To move the blocks, the workers used collapsible steel hinged "V"-shaped "pins" attached to the end of the hoisting cables and inserted these in the holes in the tops of the blocks. These hinges slipped in easily and expanded in a "V" fashion when upward tension was applied. The pins locked in the hole, enabling lifting of the blocks. After setting the blocks, tension taken off the cable allowed collapse of the "V" of the pin and removal.

As the courses rise, the thickness of the granite blocks and the concrete backing diminishes. Blocks set at the base were the largest. Each of these was 45 inches tall and weighed up to 5 tons. Above these, the blocks were 42 inches tall. Each tier was progressively thinner and lighter, with the blocks at the top weighing around 2 tons each. Some of the blocks in the observation deck weigh as much as 4.5 tons. The wall thickness ranges from slightly less than 9 feet at the base to 4 feet at the top, including the granite exterior. However, to counter the optical illusion of the column appearing thinner in the middle, the taper of the column swells halfway up, incorporating a 4-inch classical Greek entasis[6] from the cord (centerline).

A yard derrick[7] located close by on the ground moved granite blocks for the lower portion of construction. This derrick consisted of a 65-foot wooden mast with a 90-foot steel boom, which moved the stone around the base of the shaft and served the concrete mixer alongside. Above the reach of this derrick, work was done from the inside of the column by two derricks set at opposite corners of a timber tower built up the center of the well, utilizing the four central concrete columns. The wooden tower built around the four octagonal concrete columns surrounding the elevator shaft served as the derrick masts, handling the weight for the derrick. Because the handled weight was above the level of the mast top, no horizontal bracing could be used. This was to prevent possible diagonal platform distortion and, in turn, possible column distortion. Braces for the derrick platform ran from the corners of the platform downward to jackscrews[8] placed in notches cored in the concrete wall backing. Within the wooden tower frame a self-dumping concrete hoist, located just below the derrick platform, lifted the concrete from within the foundation to the necessary level of pouring.

The yard derrick supplied concrete to the concrete bins and mixer at the outside of the shaft. Concrete was discharged into the chute in the side of the foundation shaft and emptied into a large bucket lifted by the concrete hoist to the desired level of granite anchoring. The central concrete hoist picked up the bucket from the center of the foundation and automatically dumped the concrete into a hopper bracketed to one side of the derrick tower. This hopper,

located several feet above the highest level of wall to be built, then distributed the concrete to the wall forms by chutes.

Workmen lowered the blocks onto a mortar bed, set them true, and plumbed them while the derrick held the weight with wooden wedges supporting them at their correct position. After slacking the derrick, mortar was packed in the open spaces until full, and the wedges were removed with remaining filling accomplished by the poured concrete.

Each setting of the derricks added about 60 feet in column construction with the wall rise so great at the upper extreme of construction, the upper courses of granite interfered with the boom position when hoisting from the ground. To accommodate for this, the builders left gaps in the wall and hoisted the final stones inside for temporary storage until they could be used to close these gaps.

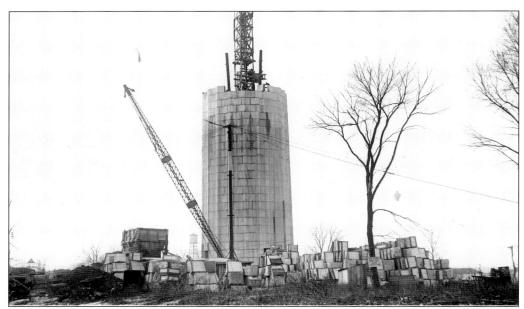

(*Top*) View of Exterior Derrick, December 16, 1913.
(*Bottom*) Steam Engine and Electric Generator Motor. No date.

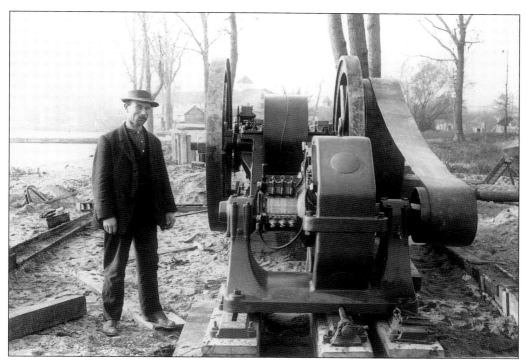

MOTOR AND COMPRESSOR, NO DATE.

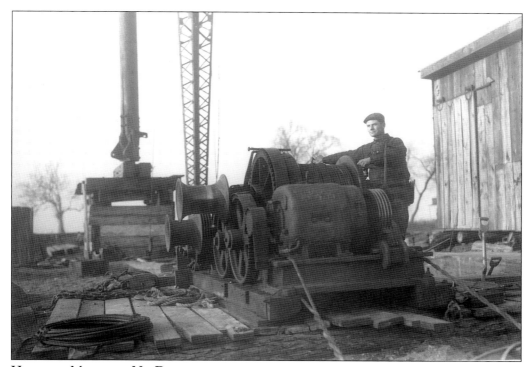

HOISTING MACHINE, NO DATE.

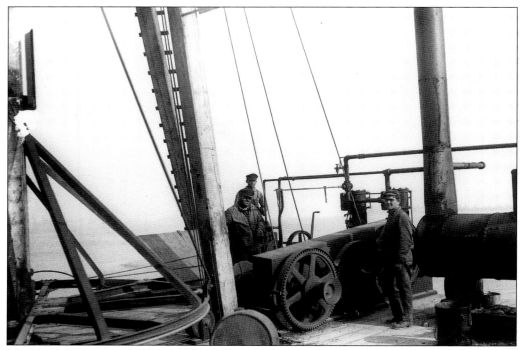

HOISTING MACHINE AT BOOM POWER PLANT, NO DATE.

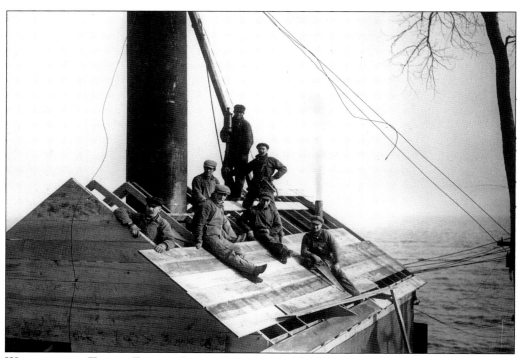

WORKMEN ON TOP OF ENGINE ROOM, JANUARY 1, 1914.

DIAGRAM OF DERRICK TOWER.

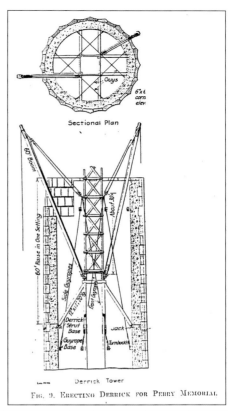

Sectional Plan

FIG. 9. ERECTING DERRICK FOR PERRY MEMORIAL.

BASE OF DERRICK AGAINST WALL OF COLUMN WITH DERRICK BRACES AGAINST WALL WITH RETAINING CABLES. The two rectangular holes just to left of each of wooden beam footing used earlier for setting metal framework, of a temporary structural nature. At foot of each wooden beam was a chain running around, which was set directly into concrete to metal fastening device, January 24, 1914.

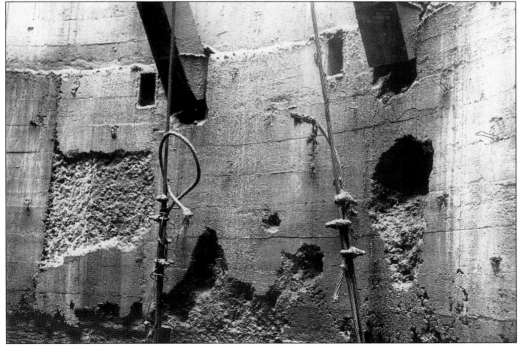

INTERIOR DERRICK BRACES SET INTO INTERIOR WALL. Wires, known as hangers, were set in concrete used for layer of bricks set on the interior, January 24, 1914.

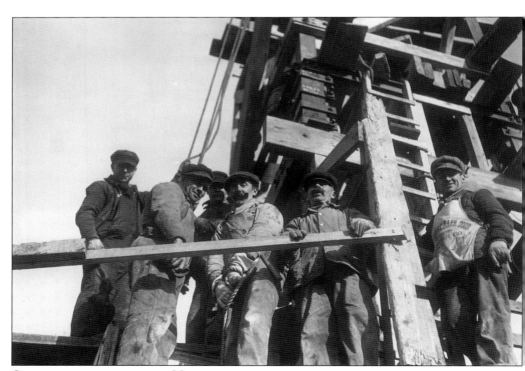

GROUP ON DERRICK TOWER. NO DATE.

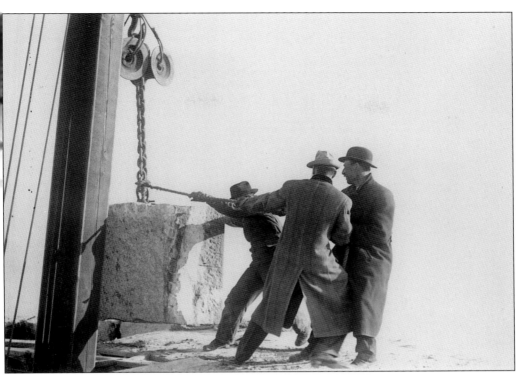

SETTING GRANITE BLOCK. NO DATE.

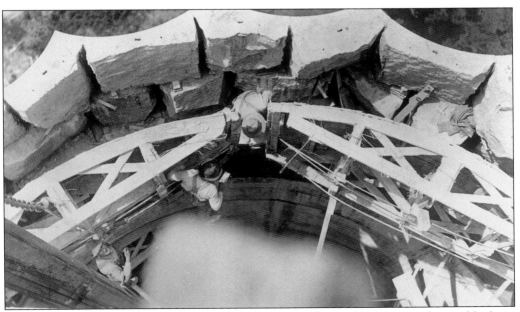

LOOKING DOWN ON FORMS READY FOR POURING. Wooden wedges were used to set blocks to proper position, c. August 1914.

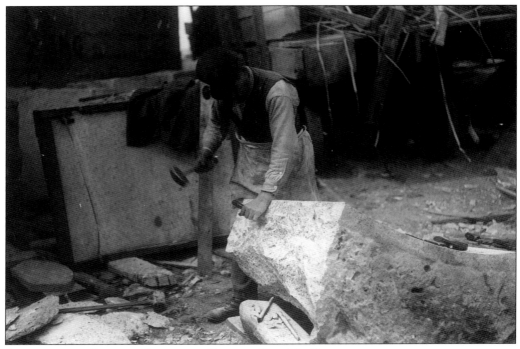

STONECUTTER SHAPING BLOCK FOR PERFECT FIT. NO DATE.

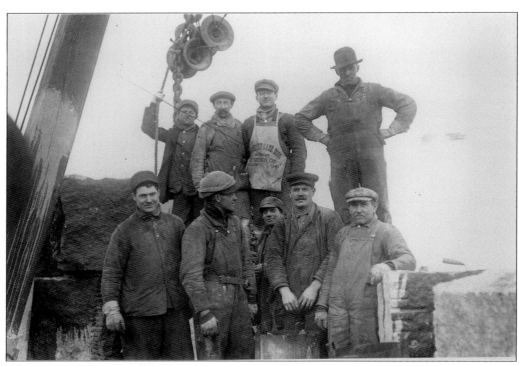

WORKERS ON COLUMN. NO DATE.

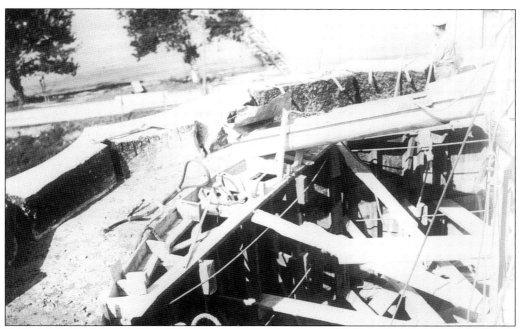

FORMS FOR CONCRETE BACKING. Opening on top of each block, which was used for lifting them. The metal pins and clamps were used to fasten blocks during pouring of concrete; chains used to raise the wooden form into place. The person is Mark Gunn, iron master. Concrete was poured from the hopper at base of column into concrete bucket, which was raised on an improvised hoist, c. 1914.

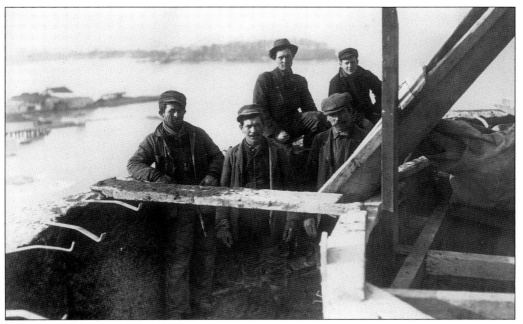

SEVERAL WORKMEN ON TOP OF COLUMN. Person to extreme left is Henry Keiner, master carpenter. Note anchors used to hold the granite blocks, c. 1914.

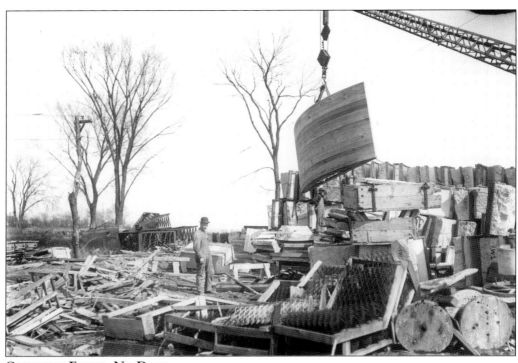

CONCRETE FORMS. NO DATE.

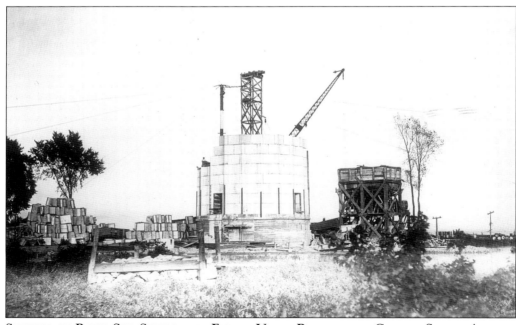

SETTING OF ROWS SIX, SEVEN, AND EIGHT; UPPER RIGHT-HAND CORNER SHOWS ACTUAL METHOD OF RAISING UNSUPPORTED BLOCKS. Wooden bumpers were removed as block was set; the steel framework was used to raise concrete bucket. With each course completed, concrete was poured to anchor each stone, August 8, 1913.

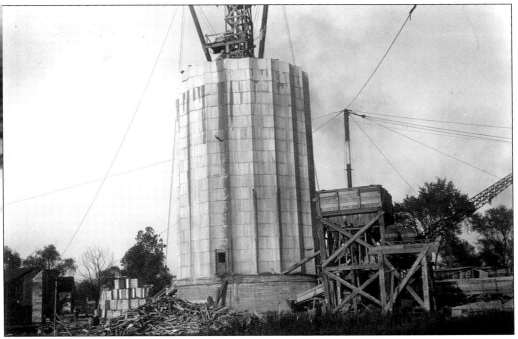

CONSTRUCTION AT THE 18TH COURSE; NOTE PILE OF DISCARDED WOOD, NOVEMBER 18, 1913.

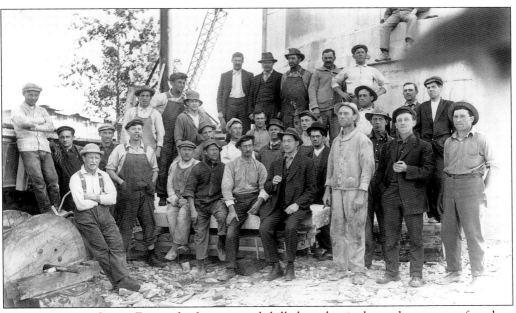

CONSTRUCTION CREW. Except for foreman and skilled mechanic, large changeover of workers during course of construction: man in suspenders and derby hat is Mark Gunn, iron master of trestle work; just over right shoulder of Gunn is Henry Fuch; person in front row in suit is timekeeper of construction; person standing to left of timekeeper is Henry Bell, foreman and straw boss, c. 1913.

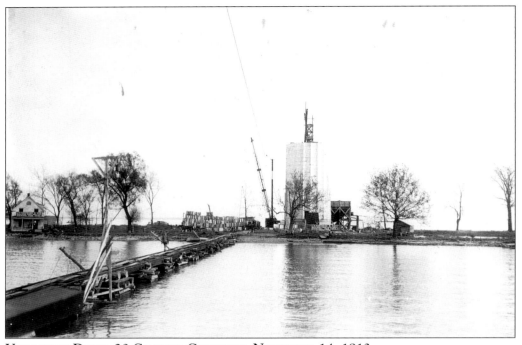

VIEW FROM DOCK; 20 COURSES COMPLETE, NOVEMBER 14, 1913.

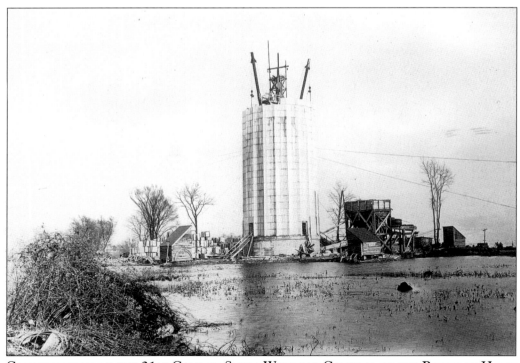

CONSTRUCTION AT THE 21ST COURSE; SHEDS WERE FOR CONTROL OF THE BOOMS BY HAND AND BELL SIGNALS TO THE BOOM OPERATOR, NOVEMBER 17, 1913.

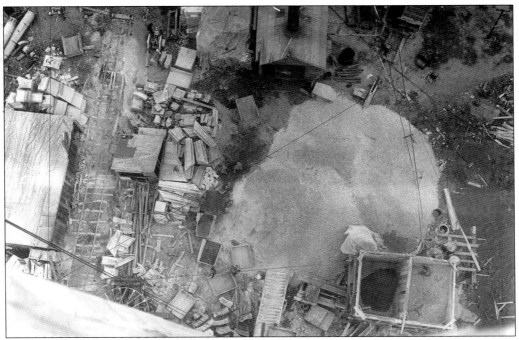

LOOKING DOWN ON CEMENT MIXER, GRAVEL PILE AND UNLOADING ZONE.

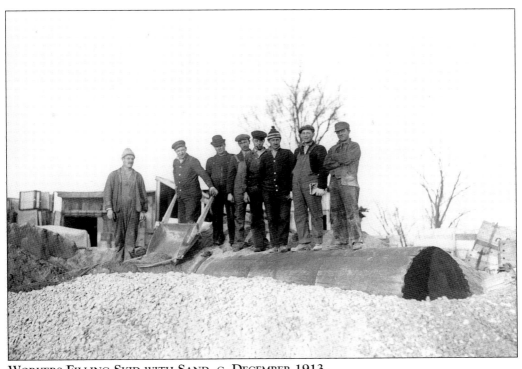

WORKERS FILLING SKID WITH SAND, C. DECEMBER 1913.

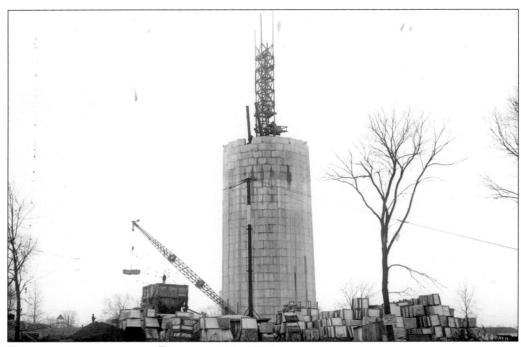

TWENTY-FOURTH COURSE, DECEMBER 16, 1913.

MARK GUNN AND MR. BELL, C. 1913.

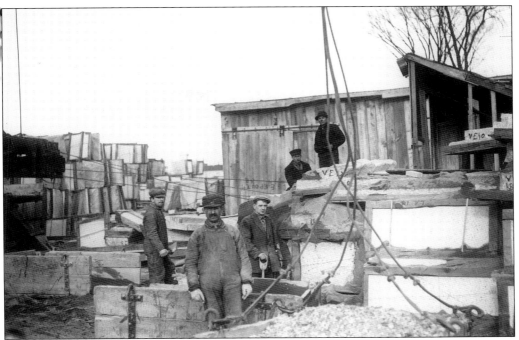

LOADING GRAVEL ONTO SKIDS, C. JANUARY 1914.

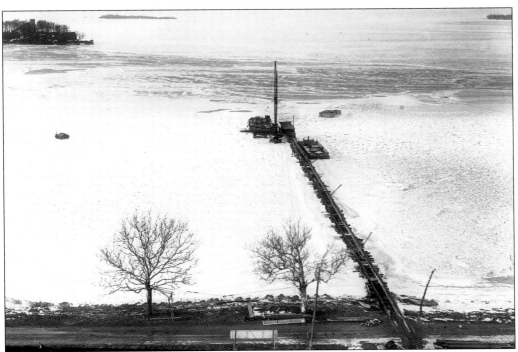

VIEW OF RAILDOCK IN WINTER. Dock itself was constructed in summer or fall of 1912. The two sycamore trees can be used for reference to other photographs, January 1, 1914.

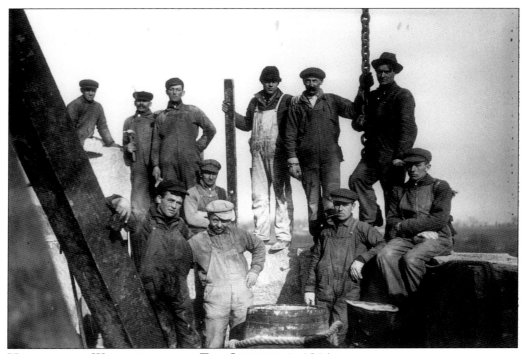

UNIDENTIFIED WORKMEN AT THE TOP, JANUARY 1, 1914.

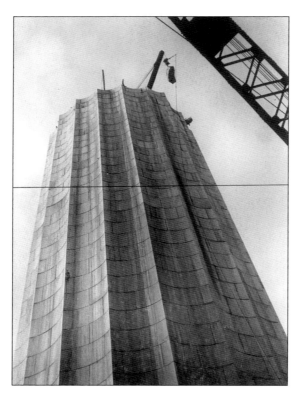

CONSTRUCTION AT THE 36TH
COURSE, FEBRUARY 5, 1914.

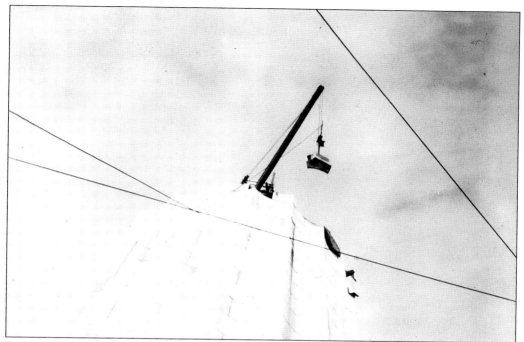

UPPER PORTION OF COLUMN WITH BOOM MOVING GRANITE BLOCK INTO POSITION.
Foreground lines are wires from the ground train, January 15, 1914.

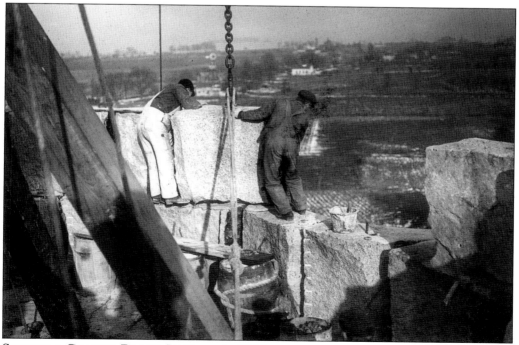

SETTING A GRANITE BLOCK, JANUARY 1, 1914.

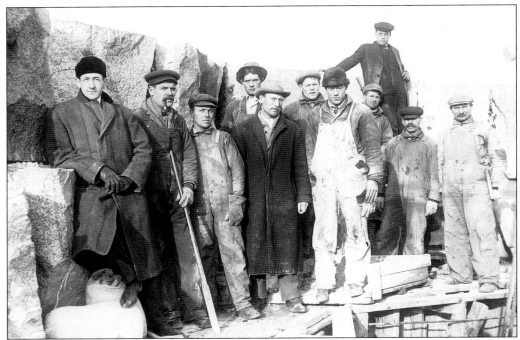

GROUP OF WORKMEN AND BOSSES WHEN WORK WAS WELL UNDERWAY. First person from left is Roy Robinson; next to him is the head stone setter. Front row fourth from left is Henry Bell, foreman, January 15, 1914.

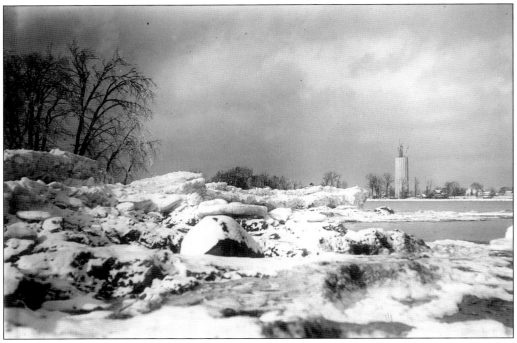

VIEW OF FROZEN SHORELINE WITH PERRY MEMORIAL IN DISTANCE, FEBRUARY 1, 1914.

38 COURSES COMPLETED,
FEBRUARY 8, 1914.

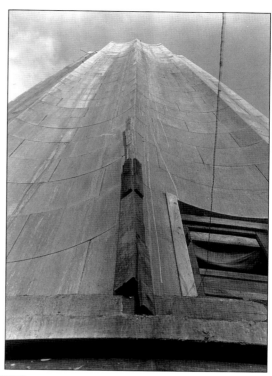

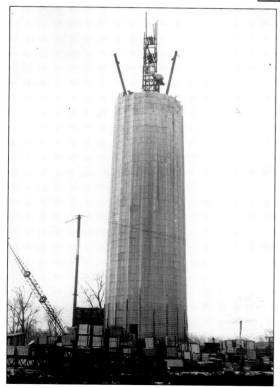

CONSTRUCTION AT THE 38TH COURSE,
FEBRUARY 8, 1914.

Top of Memorial Looking Down. Man Inspecting Forms, February 20, 1914.

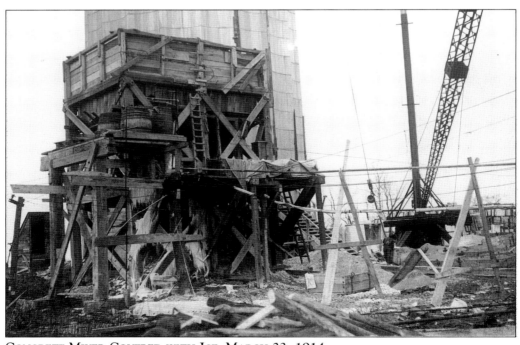

Concrete Mixer Covered with Ice, March 23, 1914.

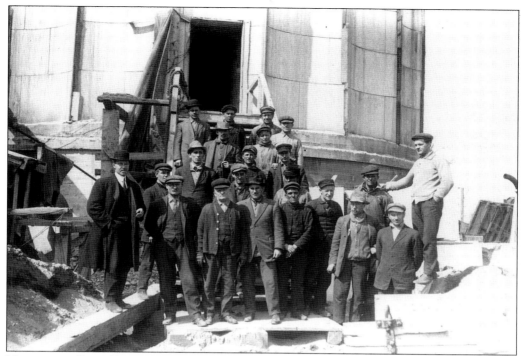

MONUMENT FULL CREW, MARCH 24, 1914.

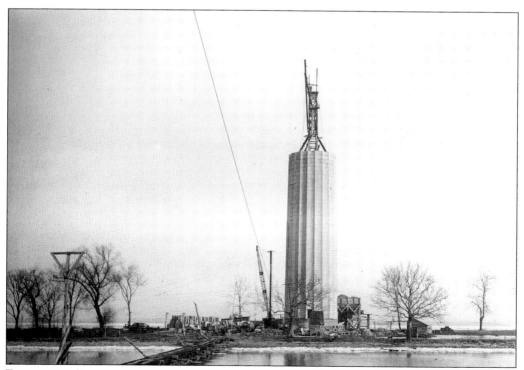

FORTY-ONE COURSES—MEMORIAL FROM END OF DOCK, MARCH 28, 1914.

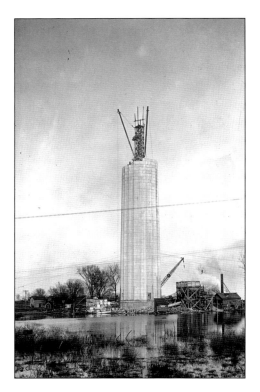

WORK INSIDE THE SHAFT

Wooden forms shaped the concrete backing of the granite blocks to form the concave walls on the inside. Spaced away from the back of the blocks, they allowed for adequate backing and anchoring by poured concrete. The forms were braced against the interior work tower and sometimes across to the opposite wall, with the anchors of the blocks wired inward to the forms. This kept the forms and granite from being moved by pressure from the poured concrete. Against this smooth interior concrete wall, a layer of bricks was laid.

Concrete pouring was limited to two courses of blocks at a time due to the header-stretcher setting of the blocks. A third course created a pocket of air difficult to fill with concrete. Robinson's crew also found the pressure of the liquid concrete behind a third course could push the facing of the stone out of true plumb, requiring countering in the setting of the next course of blocks.

The interior well has a single 4-inch brick lining for aesthetics. The interior brick lining, kept far below the exterior wall work, was laid by workers standing on a ring-shaped safety scaffold hung from cross-timbers. A small amount of lime added to the Portland cement used in the mortar aided in hardening and helped control moisture. Wire loops placed into the concrete wall served as hangers for the wall of bricks and highly non-absorbing type (Kittanning) bricks further reduced the likelihood of moisture damage.

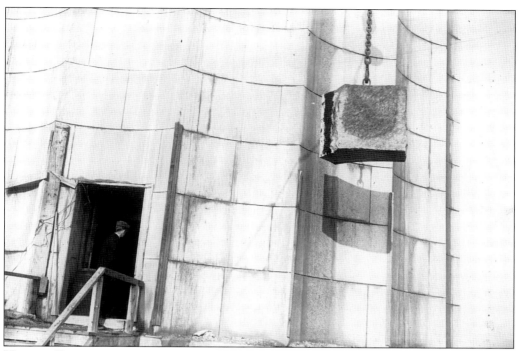

VIEW OF ENTRANCE; NOTE RAISING OF GRANITE BLOCK, April 4, 1914.

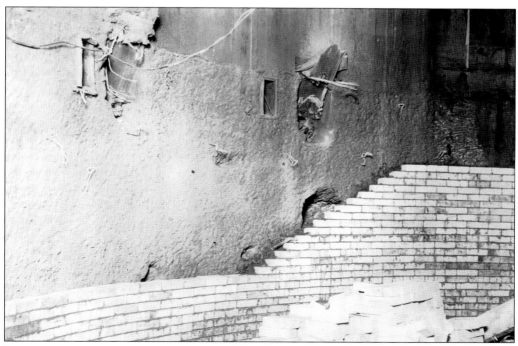

INTERIOR BRICKS SET AGAINST POURED CONCRETE WALL. This photo was taken as a result of the death of a workman by a falling brick, April 18, 1914.

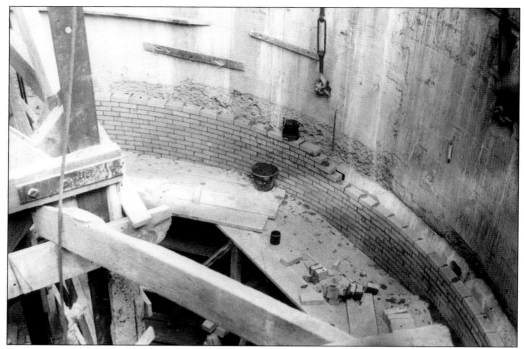

Laying Bricks in the Interior of the Column, January 1, 1914.

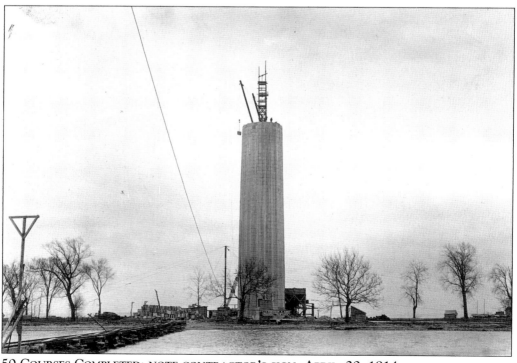

50 Courses Completed; note contractor's sign, April, 20, 1914.

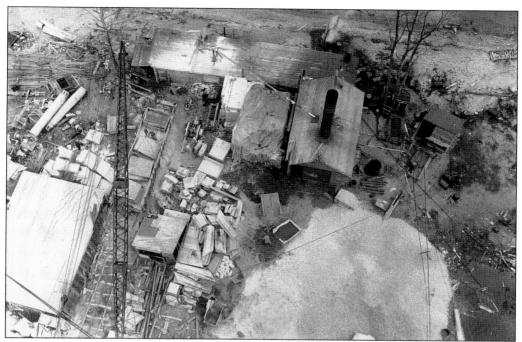

GROUNDS FROM TOP OF 50 COURSES, APRIL 20, 1914.

INTERIOR WALL WITH HANGERS FOR BRICKS.

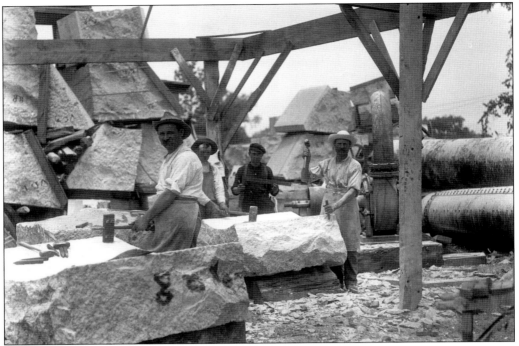

STONECUTTERS ON THE GROUND, JUNE 18, 1914.

INTERIOR STAIRCASE

The four interior concrete columns support the staircase, which surrounds the elevator shaft. The stairs and their supporting columns were cast in stages of about 25 feet or the height of a full turn of four flights. Column forms or molds were set with electric-wire conduit inside to supply electricity to the top. Before casting, the form for the column was placed and plumbed to straightness and concrete poured up to the bottom of the next stair-landing. A section of each column, joined to a landing, was cast along with the landing. A horizontal brace extending from each column out to the interior monument wall was poured at the same time. These braces connected to a recess which was molded in the concrete wall, creating radial struts running from the columns to the interior wall at 25-foot intervals and preventing interior column sway.

The stairs consisted of reinforced-concrete stringers[9] on either side, with each stringer holding continuous tread[10] and risers[11] reinforced with steel. The crew set the tread and riser just equal to the stair width and bent to the required stepped shape of their respective forms. The sheets dropped in place and merely needed a few small wooden blocks to hold them off the bottom form. This entire staircase runs from the lower elevator landing to the upper elevator landing and consists of 427 steps.

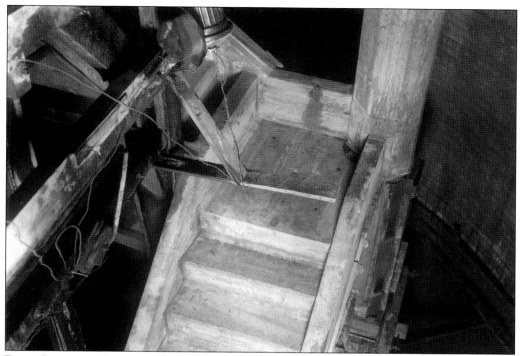

BARE CONCRETE INTERIOR STAIRCASE, APRIL 19, 1914.

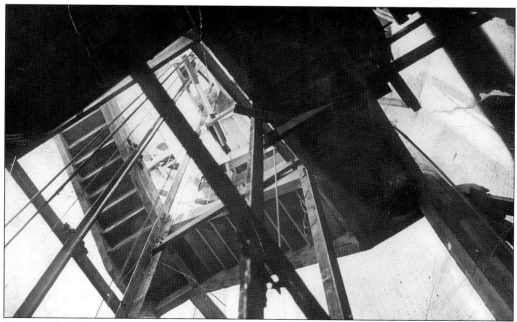

VIEW OF INTERIOR STAIRCASE, C. 1915.

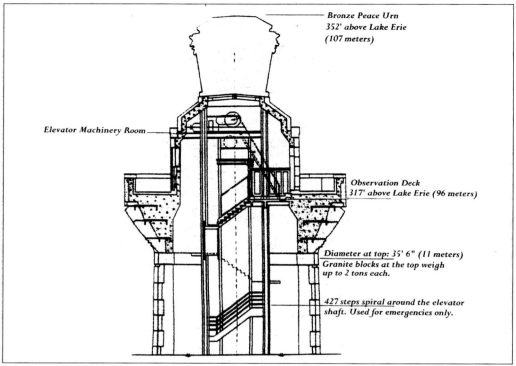

Bronze Peace Urn
352' above Lake Erie
(107 meters)

Elevator Machinery Room

Observation Deck
317' above Lake Erie (96 meters)

Diameter at top: 35' 6" (11 meters)
Granite blocks at the top weigh
up to 2 tons each.

427 steps spiral around the elevator
shaft. Used for emergencies only.

DIAGRAM B OF STAIRS.

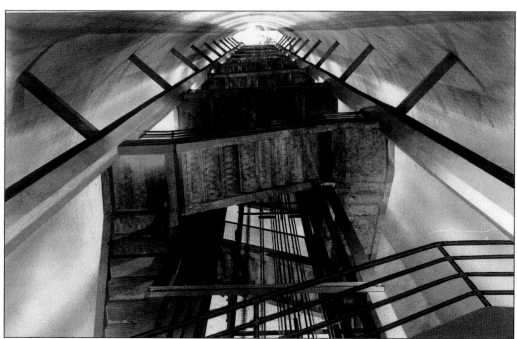

LOOKING UP INTERIOR OF COLUMN AT STAIRCASE AND ELEVATOR CABLES, C. DECEMBER 1914.

ECHINUS ASSEMBLY

A year after the cornerstone laying, in early July of 1914, the crew placed the 78th course. The next course of blocks began what is referred to by architects as the echinus[12]. Work on this course called for special measures to ensure maximum safety and optimum structural integrity. Each course required full setting before work on the next one could begin.

Using the cap as an observation deck made providing for the safety of visitors imperative. Tapering out to the overall 16-foot cantilever[13] at the corners of the observation platform necessitated a gradual flaring out from column diameter to the horizontal abacus accomplished by each successive course of the echinus having a cantilever. The exterior of the 78th course has a 4-inch high by 4.25-inch deep recess around the top of these blocks called sinkage[14] (see diagram C) and is for decorative effect.

The 79th course is referred to by architects as the necking[15] (see diagram C) of the column and looks much like the lower courses with no cantilever. These blocks, however, are deeper than the blocks of other courses, which exposes them on the interior well (see diagram B). This separates the greater anchoring requirements for cantilevered blocks above from the column's vertical block backing below. The 79th course required no concrete backing for anchor and rests on top of the lower blocks and their concrete backing. To prevent shifting, there are cramps set in the top and bottom of these blocks and held in the concrete backing above and below. The new anchor bed above the 79th course accommodates the greater anchoring requirements for the cantilevered blocks. Because the blocks run deeper toward the interior well, there is a 4-inch ledge at this level around the interior of the column used for support of an interior platform around the elevator shaft. The 79th course marks the end of actual vertical block facings. Each successive higher course of the echinus after the 79th cantilevers above the previous and distributes the weight of the abacus top around a greater monument column diameter.

The 80th course is where the difference in the echinus construction becomes evident. Besides having four decorative horizontal lines or fillets[16] (see diagram C) that run the circumference of the column separating the necking from the echinus, these blocks also flare outward and upward with a cantilever of 1.5 feet. The tendency for these blocks to fall off the outer edge was countered by cables connected to the blocks and wired inward to hold the blocks in place until anchored. The next course is cantilevered about 2.5 feet past the previous course with a plain smooth face. The 82nd and final course of the echinus is just like the previous one, but with a cantilever of almost 2 feet. This gives the echinus a cantilever radius of approximately 6 feet with a diameter of 47 feet 6 inches.

Due to the greater tension stresses acting on the cantilevered courses, each block utilized a cramp[17] to hold it in place. In this case, the cramp consisted of a longer anchor about 3-feet long by half-inch wide that runs from the top-hole back downward into the concrete (see diagram D). This ensures the cantilevered blocks stay anchored once the backing concrete set. Because pressures acting on the blocks of these courses forces them outward and downward, it was imperative that each echinus course be fully finished before work began on the next. The echinus comes to the edge at the center of each side of the abacus (see next section), leaving the corners of the abacus with a cantilever of 10 feet.

DIAGRAM C OF DORIC COLUMN.

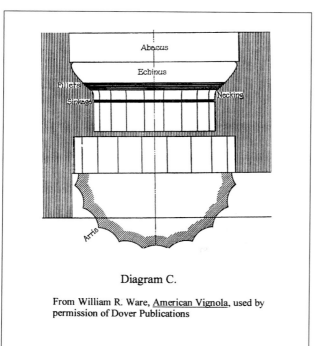

Diagram C.

From William R. Ware, <u>American Vignola</u>, used by permission of Dover Publications

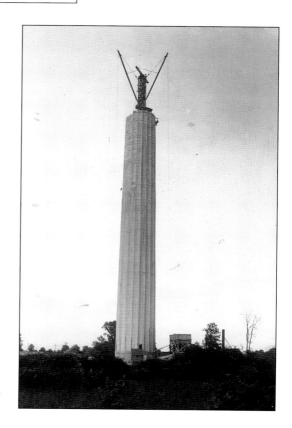

BEGINNING CONSTRUCTION AT THE 79TH COURSE, C. AUGUST 1914.

SEVENTY-NINTH COURSE PARTIALLY COMPLETED,
c. AUGUST 1914.

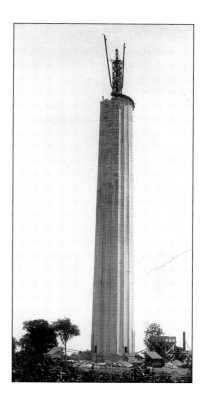

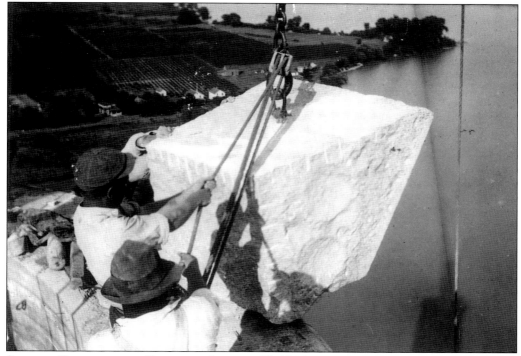

SETTING CANTILEVERED BLOCK, c. AUGUST (?) 1914.

ROY ROBINSON SITTING ON PARTIALLY COMPLETE ECHINUS. Note cables holding blocks, c. September 1914.

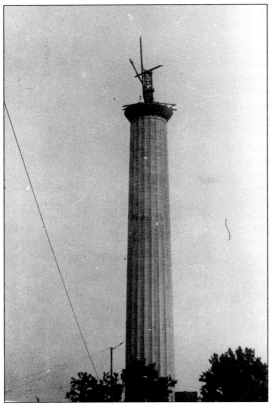

ECHINUS FINISHED; BEGINNING WORK ON ABACUS, C. SEPTEMBER 1914.

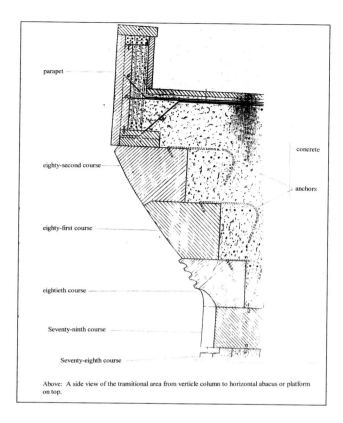

parapet

concrete

anchors

eighty-second course

eighty-first course

eightieth course

Seventy-ninth course

Seventy-eighth course

Above: A side view of the transitional area from verticle column to horizontal abacus or platform on top.

ABACUS ASSEMBLY

An abacus[18] of a 47-foot 6-inch square platform with a depth of 7 feet 6 inches, surmounts the echinus at the top of the column. At the center of this cap, a penthouse shelter with a 17-foot tall domed roof, supports an 11-ton decorative bronze urn. The structural design of the abacus, due to architectural requirements, was unusual and difficult to erect, requiring carefully devised construction outfitting and precise placement of materials under difficult conditions. The immense length and depth of the abacus was necessary to serve as an open-air lookout so visitor safety required construction of a parapet[19]. To prevent chance of discoloration from metal fastenings, construction of the parapet used only granite and concrete.

The soffit[20] of the abacus consists of 52 12-inch thick granite beams placed radially around the top of the echinus radiating like spokes of a wheel. Each beam was cut with a taper along its length so as to fit flush against one another around the top and form the square of the platform (see diagram E). The weight of the penthouse helps to counteract the forces acting on the cantilevered soffit beams supporting the floor.

The weight of the corner beams hanging beyond their centers of gravity (cantilever) causes the central/inward ends of the granite beams to flip up. Although the echinus helps to lessen this

force, additional measures were taken to help counter this tendency. Since the cantilevered corner beams would fall over the sides if left without an anchor, the abacus required complete assembly and support (falsework) before construction could continue. To accomplish this, a wooden frame with a block and tackle straddled each corner and supported the granite beams with a timber from underneath. In doing this, neither rods nor other temporary members penetrated the concrete or granite construction, eliminating the need to patch or fill holes in the facing of the finished column. Trimming the upper edges of the 1-foot thick granite beams down 6 inches made the top surface of the beams form a dovetail[21] projection (see diagram E).

Placing edges of the beams next to each other, they formed a full dovetail groove able to receive concrete and surround the top dovetail protrusion. Although sufficient to hold the beams in place, the walls and domed roof of the elevator head house were built structurally as a unit with the column rather than with the parapet to help secure the cantilevered soffit beams in place.

Setting and clamping outer parapet wall face "shingles" securely in place served as forms to hold poured concrete on the dovetailed soffit tops. Thirteen granite shingles per side make up the outer parapet faces. The backs of these shingles have dovetail extrusions similar to those along the center of the tops of the abacus soffit beams. Fifteen smaller granite shingles with dovetail extrusion backs make up one interior parapet wall and are held when surrounded by the poured concrete. The walls formed were capped with 6-inch thick granite slabs held in place by framework allowing for concrete pouring and granite tiles placed on the surface created the parapet floor.

Concrete poured over and into the abacus base, with the outer walls of the parapet serving as forms to hold the concrete, filled up dovetail grooves (recesses) and surrounded dovetail extrusions, locking all pieces in place. This cap design called for three things: a floor 3 feet 6 inches thick that supports its own weight, a live-load or working load of 100 pounds per-square-inch, and parapet beams holding the sides of the parapet. The unique construction of the parapet abacus, completed on August 31, 1914, took place nearly a year after the officers were laid to rest under the rotunda.

Completion of the abacus allowed for the extensive process of sandblasting the monument to begin. Wooden timbers straddling the corners of the abacus suspended workers and their equipment on scaffolds close to the column side. This extensive process over the height of the column gave the granite as brilliant a texture as possible. Sandblasting the blocks with fine vertical lines creates the same effect as the cutting of facets on precious stones: a sparkle, and a play of light that is appealing.

With the parapet completed, work began on the penthouse housing the elevator motor works, which visitors would later walk into as they exit the elevator at the end of their ascension to the observation deck. The walls of the penthouse are made of rectangular granite blocks. Wooden forms were placed near their inner sides and concrete poured between to create granite exterior walls backed with hardened concrete to anchor them. The interior corners were also filled with concrete to create a semi-circular base on which to construct a round domed ceiling. The next step was challenging: forming the domed roof of the penthouse.

The penthouse roof rising over 17 feet above the abacus, supports an 11-ton, decorative, 8-legged, bronze "urn" over 22 feet tall. Creating a roof able to handle this load required the same hardened concrete used throughout construction. Careful placement of wooden forms on top of the penthouse walls shaped the bottom layer of the round domed concrete ceiling. After finishing a layer, a smaller similar set of forms spaced above the previously poured rounded ceiling continues the decreased diameter and the dome. As visitors exit the elevator at the top, the impression of the wooden boards that made up the forms can be seen in the ceiling. A single row of small granite blocks, set along the upper and lower rim of the roof, finished the domed portion of the roof top.

Pouring the roof in October of 1914 ended that part of monument construction and required large amounts of concrete. Workmen disassembled the wooden tower frame that carried the concrete bucket. They then finished the center of the rotunda floor and ceiling and installed an elevator. Finally, the decorative bronze urn, over 22 feet tall, was placed on top.

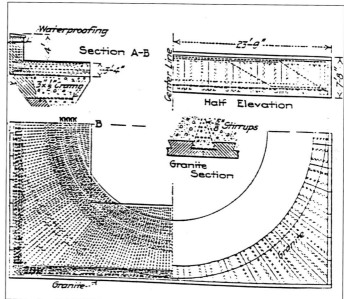

FIG. 1. REINFORCEMENT OF COLUMN CAP, PERRY MEMORIAL COLUMN, PUT-IN-BAY, OHIO

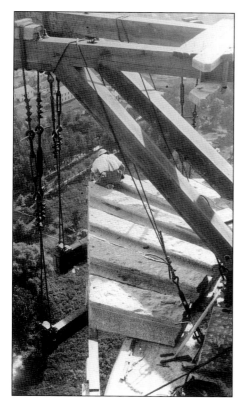

SETTING BASE OF PARAPET, C. SEPTEMBER (?) 1914.

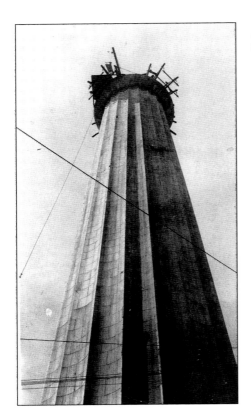

ABACUS WITH ONE CORNER SET,
C. SEPTEMBER 1914.

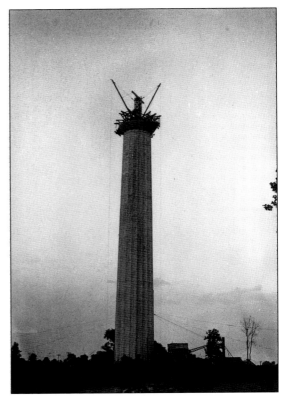

SETTING PARAPET "BEAMS,"
C. SEPTEMBER 1914.

PARAPET BEAMS IN PLACE,
C. SEPTEMBER 1914.

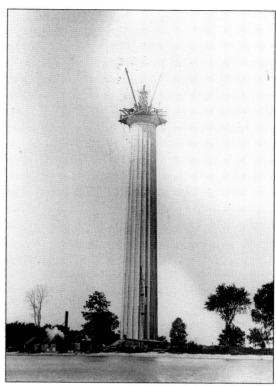

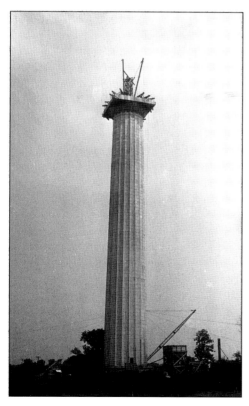

ABACUS NEAR COMPLETION,
C. SEPTEMBER 1914.

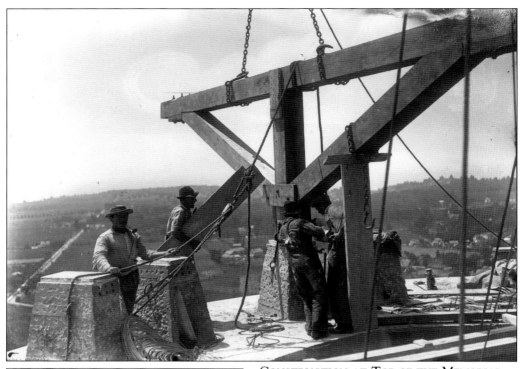

CONSTRUCTION AT TOP OF THE MEMORIAL, c. SEPTEMBER (?) 1914.

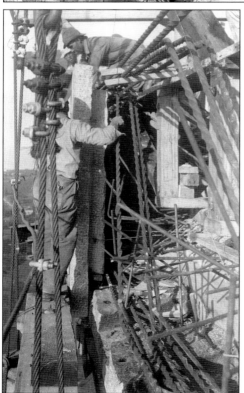

SETTING GRANITE FACE ON ABACUS OUTER WALLS, c. SEPTEMBER 1914.

GRANITE FACE ON ABACUS SET,
C. SEPTEMBER 1914.

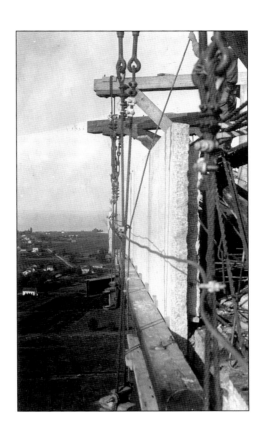

BACK OF GRANITE FACING STONES OF ABACUS, C. SEPTEMBER 1914.

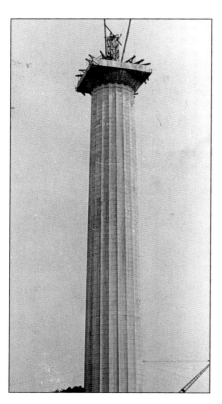

WORKING ON FLOOR OF ABACUS,
C. SEPTEMBER 1914.

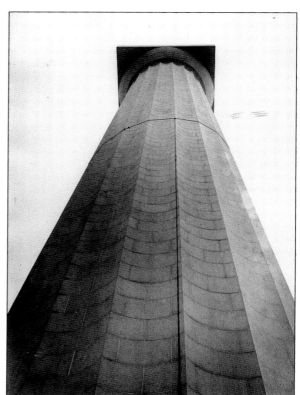

LOOKING UP MONUMENT AT
OBSERVATION DECK,
C. SEPTEMBER 1914.

PARAPET UNDER CONSTRUCTION.
Timbers on corners suspended
sandblasting, c. September 1914.

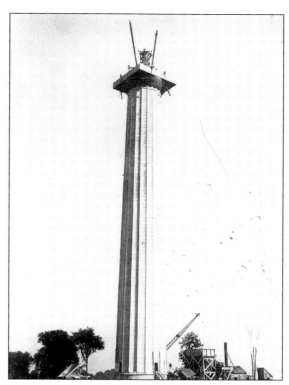

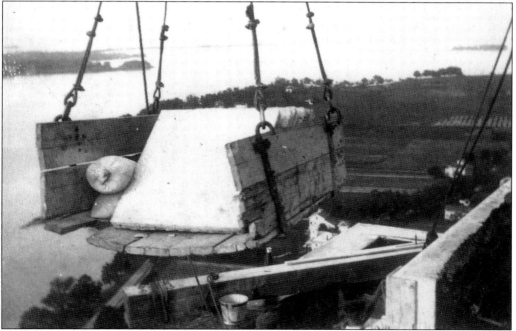

TRANSPORTING SHINGLES OF GRANITE TO TOP; note sandbags used for holding shingles in place and large beam used for support of sandblasting rig. Middle Bass Island can be seen in the distance, c. September (?) 1914.

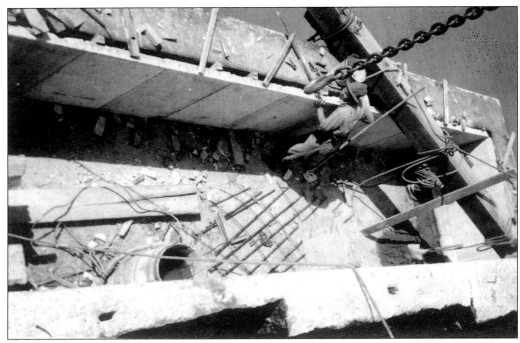

PARAPET SHOWING GRANITE SLABS BEING SET IN PLACE ALONG INSIDE OF WALL; beam used for support of sandblasting rig, c. September 1914.

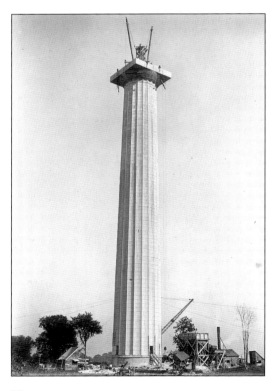

FINISHING PARAPET WORK PRIOR TO PLAZA CONSTRUCTION BEGINNING, c. OCTOBER 1914.

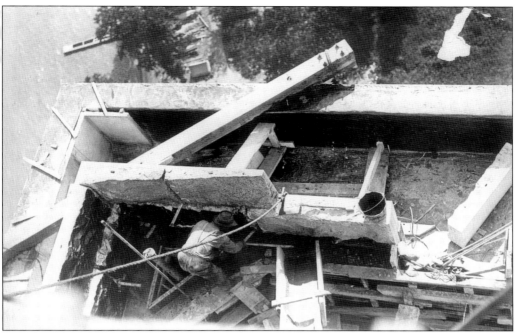

BEGINNING WORK ON PENTHOUSE. Beam used to support sandblasting scaffold, c. September 1914.

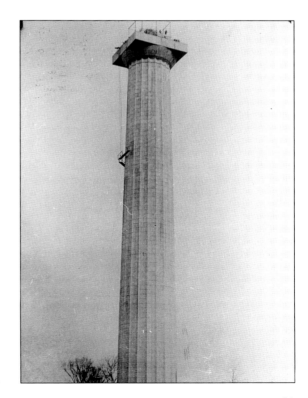

VIEW OF PARAPET. Note man within penthouse framing, c. September, 1914.

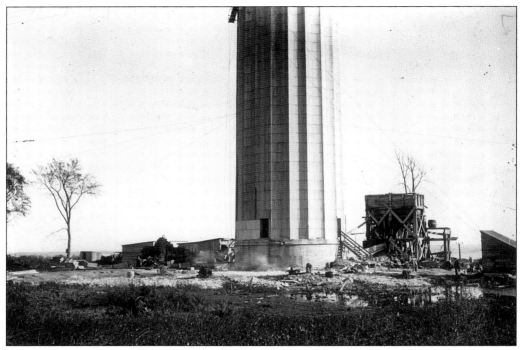

SANDBLASTING IN PROGRESS. Blocks in lower left already blasted, November 4, 1914.

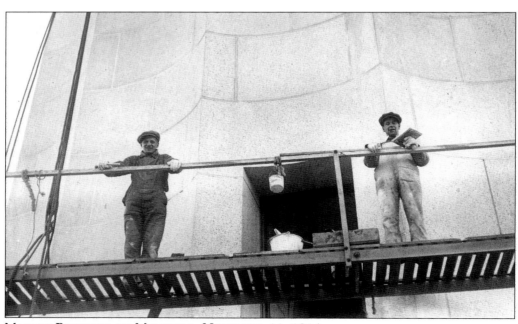

MASONS POINTING ON MEMORIAL, NOVEMBER 11, 1914.

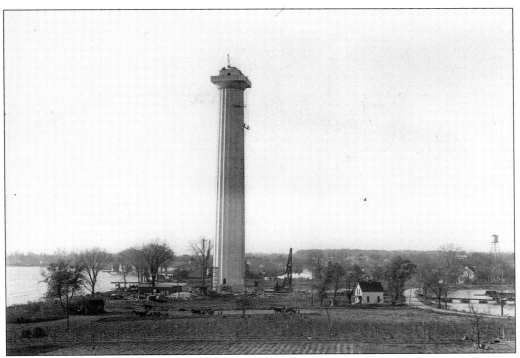

SANDBLASTING CONTINUES, NOVEMBER 14, 1914.

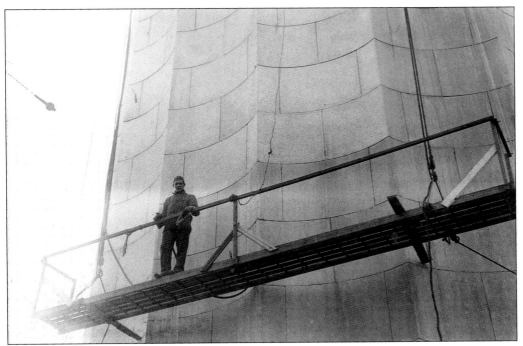

SANDBLASTER ON SCAFFOLD, NOVEMBER 9, 1914.

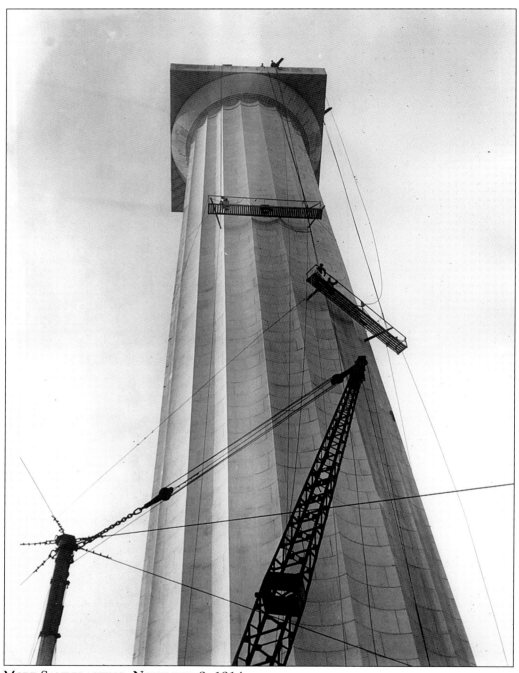

MORE SANDBLASTING, NOVEMBER 9, 1914.

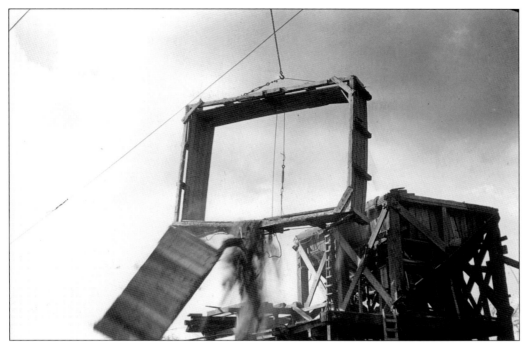

TAKING DOWN CONCRETE MIXER, NOVEMBER 9, 1914.

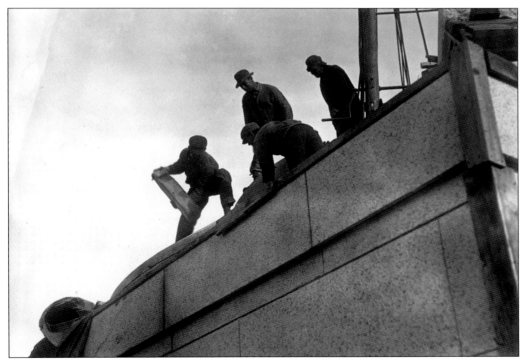

SETTING FORMS FOR DOMED ROOF, NOVEMBER 13, 1914.

WORKING ON BASE OF URN, NOVEMBER 18, 1914.

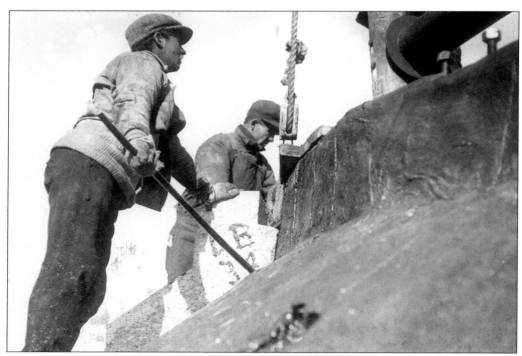

SETTING GRANITE AT BASE OF URN, NOVEMBER 18, 1914.

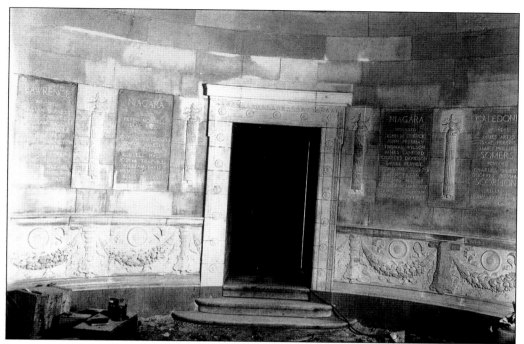

ROTUNDA WALL LISTING U.S. KILLED AND WOUNDED FROM BATTLE OF LAKE ERIE, C. 1914.

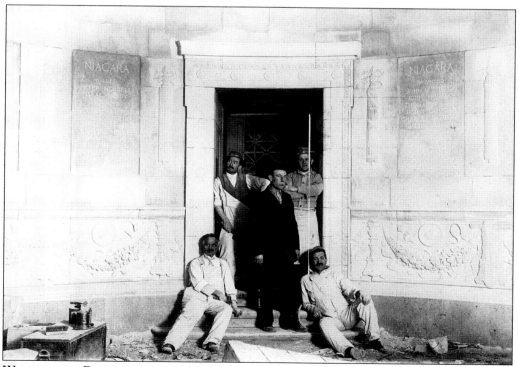

WORKMAN IN ROTUNDA, C. 1914.

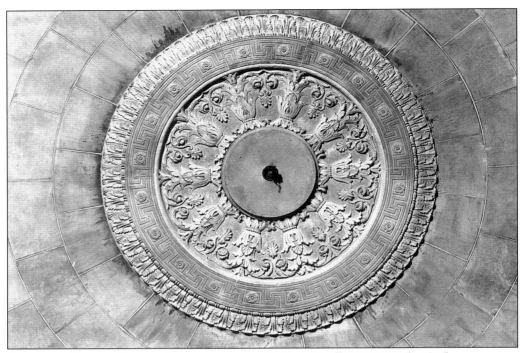

ROTUNDA CEILING BEFORE CHANDELIER WAS INSTALLED, FEBRUARY 15, 1915.

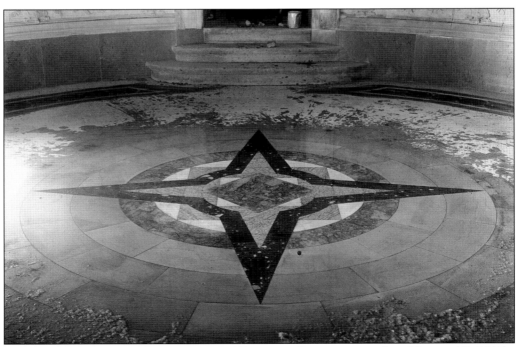

ROTUNDA FLOOR AFTER PHOTOGRAPHER HERBSTER CLEANED IT OF ICE, MARCH 17, 1915.

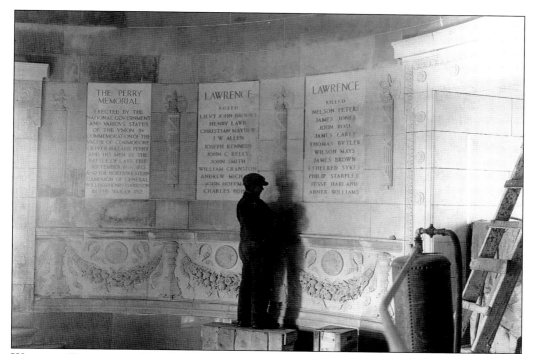

WORKERS ENGRAVING PLAQUES IN ROTUNDA, MARCH 16, 1915.

BRONZE URN

Joseph Freedlander, the monument co-architect, designed the 22.5-foot by 17-foot 4-inch diameter bronze, 8-legged urn. The Gorham Company, Architectural Bronze Division, located in Providence, Rhode Island, cast the urn and assembled it at the foundry. After checking for sizing, it was disassembled and brought to Put-in-Bay. With the eight legs of the urn anchored to the roof and scaffolding placed around them, workers were able to finish its construction. Inspection and placement of the $14,000 bronze urn on the top marked the end of the work to construct the Perry's Victory and International Peace Memorial itself. The pavement immediately around the base of the new monument was the final phase of construction.

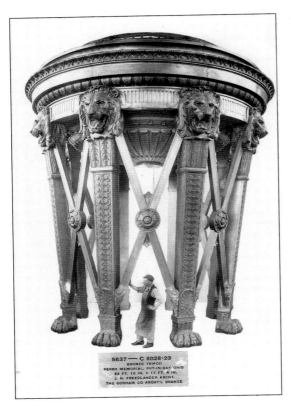

BRONZE URN CONSTRUCTED BY THE GORHAM FOUNDRY WORKS IN PROVIDENCE, RHODE ISLAND, C. 1914.

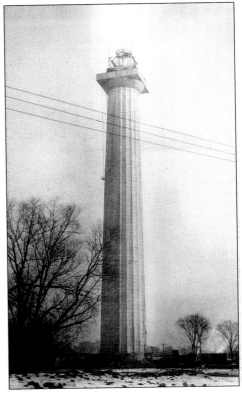

MEMORIAL FROM BATHING BEACH—FRAMING AROUND URN, JANUARY 5, 1915.

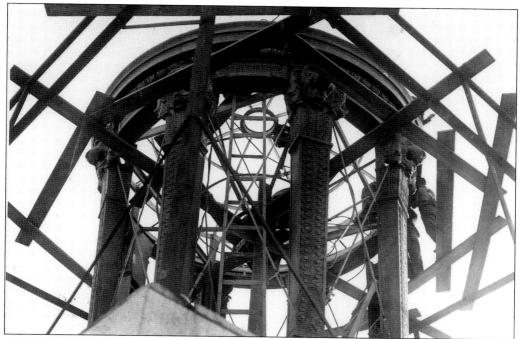

BRONZE URN IN PLACE SURROUNDED BY SCAFFOLDING AND WORKERS ASSEMBLING IT ON ROOF, JANUARY 15, 1915.

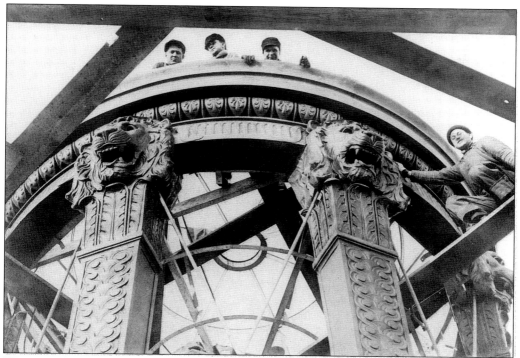

WORKERS LOOKING DOWN FROM URN BEING ASSEMBLED, JANUARY 15, 1915.

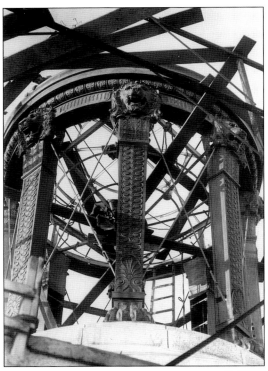

CLOSE-UP OF URN, JANUARY 15, 1915.

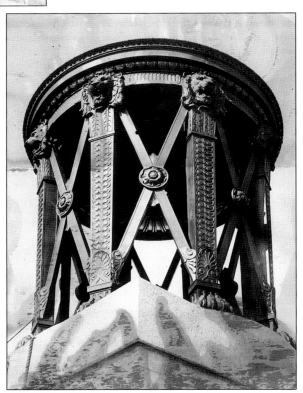

FINISHED URN ON TOP OF COLUMN,
c. JANUARY 1915.

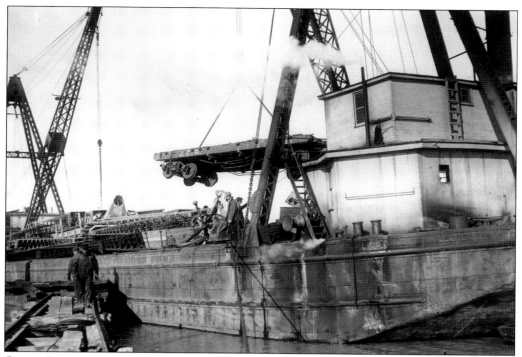

GREAT LAKES BARGES BEING LOADED (ROBINSON LEAVING), NOVEMBER 28, 1914.

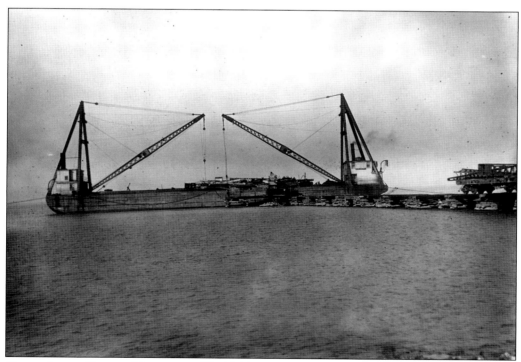

GREAT LAKES BARGE, NOVEMBER 25, 1914.

Plaza Construction

The final segment of completing the monument construction consisted of the esplanade, or plaza, around the base. Due to consistent disharmony in their professional relationship, Freedlander did not want to continue with Robinson as contractor for the plaza, so the Stewart Engineering Corporation of New York City was contracted in October 1914.

The original design called for a monument surrounded by a concrete plaza extending 460 feet from shore to shore of the isthmus. A 760-foot-long cross shape, complete with a museum and a temple of peace, gave the entire plaza an area of almost 5 acres. Besides supplying an appealing architectural base for the monument, the plaza was intended to provide a stunning location for exercises and ceremonies requiring room for large groups. A shortage of funds, however, required Freedlander and Seymour to redesign a modest plaza of only 160 square feet on just the upper plaza, eliminating the museum and peace temple. This modified design retained an architectural base for the general visual composition of the memorial.

Initial plaza work consisted of leveling and filling the surrounding ground around the monument before actual construction of the plaza began. The plaza surface, built 12 feet above mean high water level, rests about 4 inches above the top of the foundation of the monument. Designed as slab-and-beam construction, it consists of reinforced concrete slabs resting on concrete beams, supported by pillars called McArthur Pedestals.

Fabricating McArthur Pedestals requires a pile driver forcing a pile point down to solid bedrock. A casing was then forced down over the pile, the point removed, and concrete poured into the casing and allowed to set. Removing the casing left a hardened concrete pedestal resting on the bedrock. Wooden forms attached to these columns and running between them created the hardened concrete beams to support the plaza. More forms were placed upon these beams, creating the flat concrete slabs supporting the final surface of the plaza. Decorative urns placed on the four corners of the upper plaza served as a finishing touch, but the shortage of funds required the original plaza surface to consist of crushed stones.

PREPARING MONUMENT GROUNDS FOR PLAZA, NOVEMBER 14, 1914.

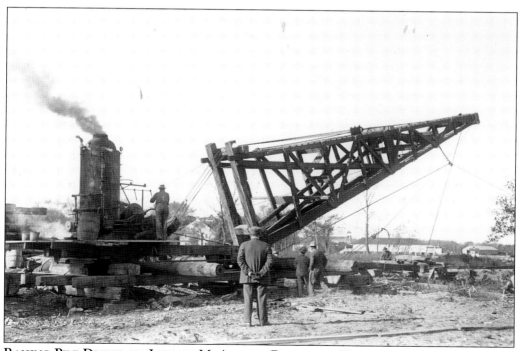

RAISING PILE DRIVER TO INSTALL MCARTHUR PEDESTALS, NOVEMBER 6, 1914.

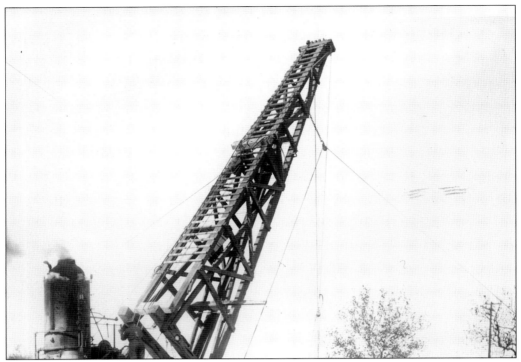

RAISING PILE DRIVER, NOVEMBER 6, 1914.

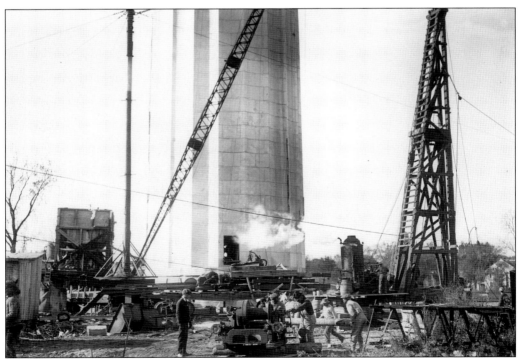

RAISING PILE DRIVER, NOVEMBER 6, 1914.

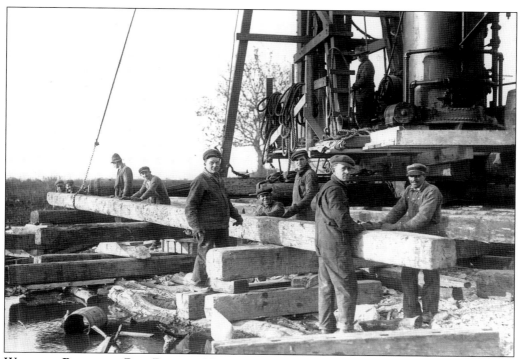

WORKERS READYING PILE DRIVER, NOVEMBER 14, 1914.

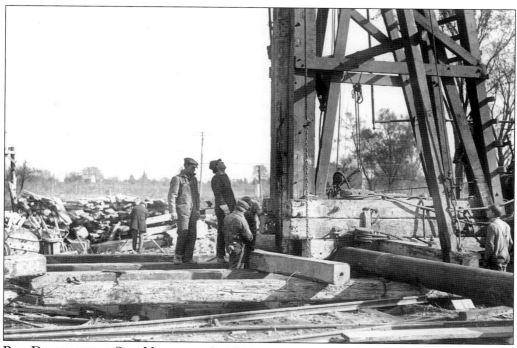

PILE DRIVER BEING SET, NOVEMBER 9, 1914.

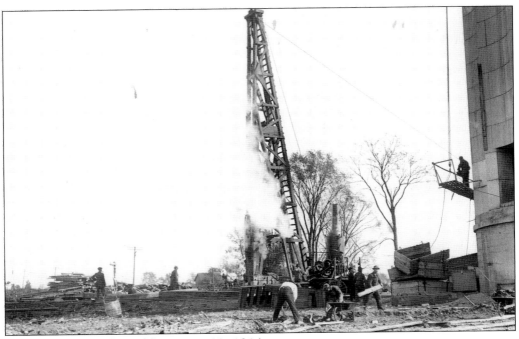

PUTTING IN FIRST PILE, NOVEMBER 18, 1914.

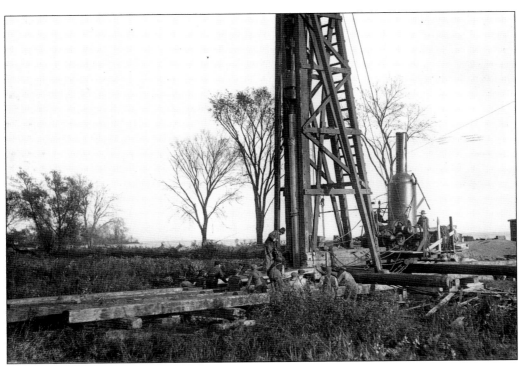

PILE DRIVING, NOVEMBER 13, 1914.

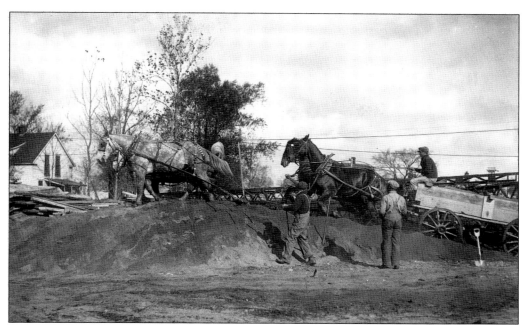

HORSES HAULING SAND, NOVEMBER 9, 1914.

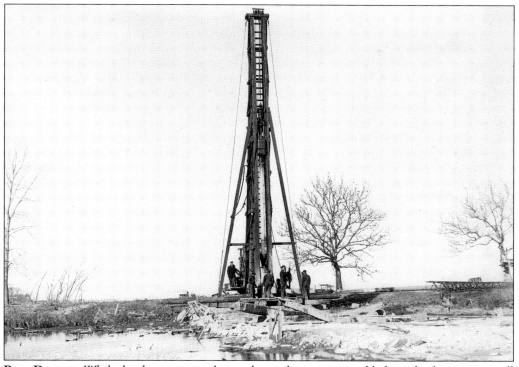

PILE DRIVER. While landscaping was being done, the crew assembled a pile driver to install McArthur Pedestals for the plaza.

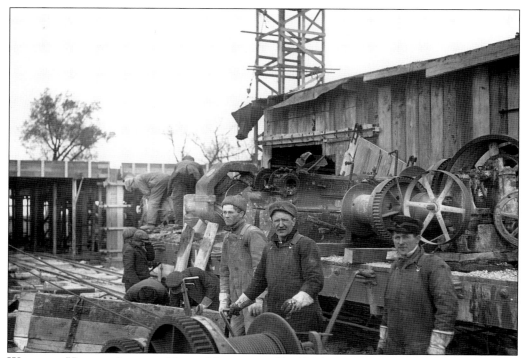

WORKERS HENRY, AL, AND MARK, NOVEMBER 22, 1914.

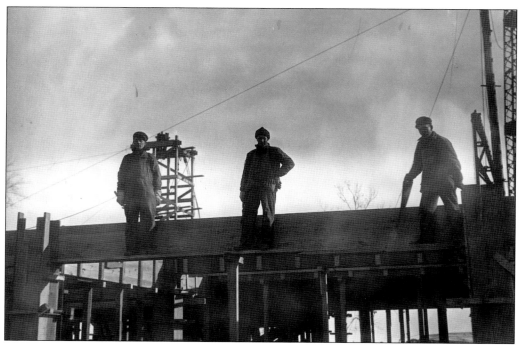

THREE CARPENTERS ON NEW PLAZA FORMS, NOVEMBER 23, 1914.

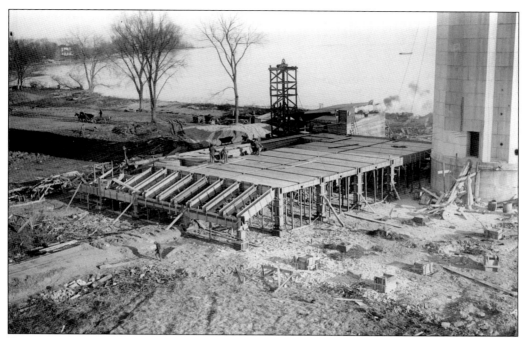

FORMS OF PLAZA READY TO RECEIVE CONCRETE, NOVEMBER 27, 1914.

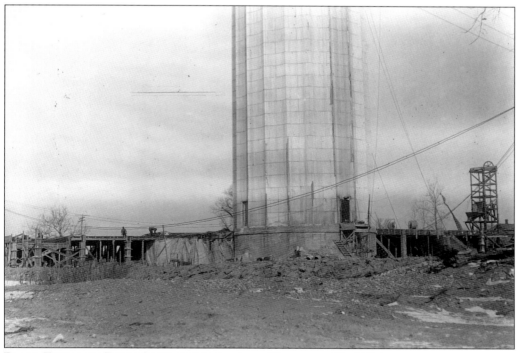

PLAZA FORMS ON BOTH SIDES OF MONUMENT, DECEMBER 31, 1914.

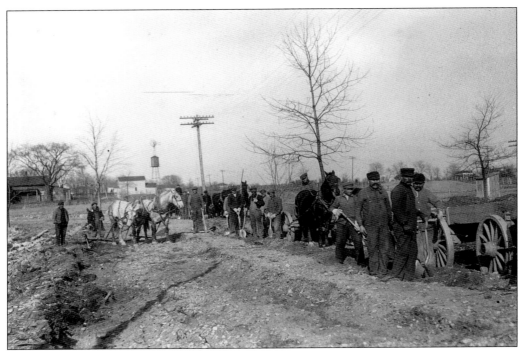

WORKERS LEVELING GROUND PRIOR TO LAYING OF PLAZA, C. JANUARY 1915.

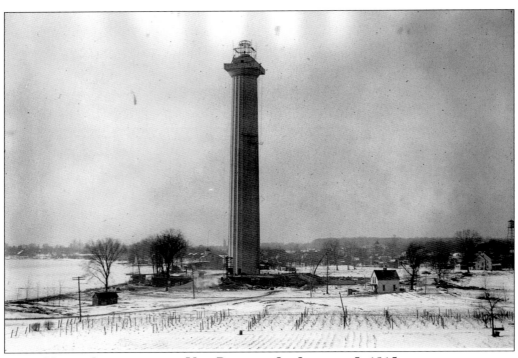

PLAZA UNDER CONSTRUCTION; URN ROUGHED IN, JANUARY 5, 1915.

STEPS OF PLAZA ARE UNDER CONSTRUCTION. Note man hanging from lower sandblasting scaffolding, February 15, 1915.

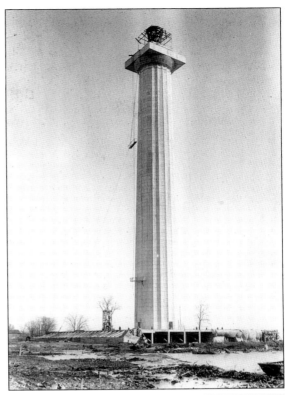

CONCRETE FORMS FOR THE PLAZA; Underside of plaza steps prior to placement of treads and risers, c. February 1915.

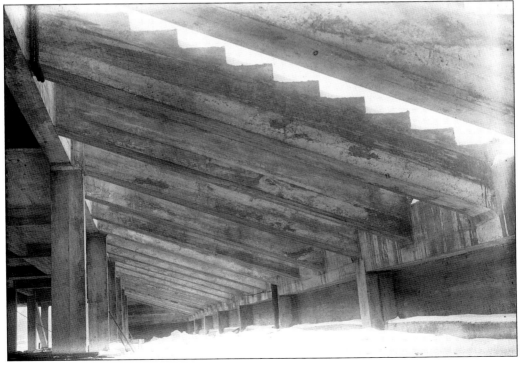

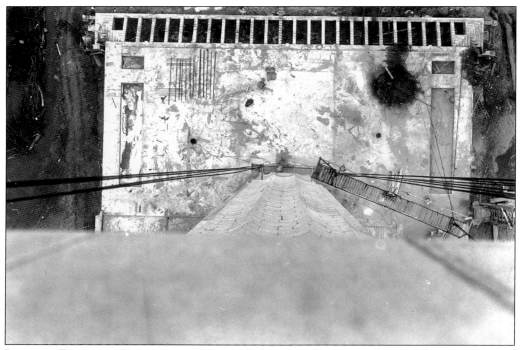

LOOKING DOWN ON PLAZA FROM TOP OF MONUMENT, FEBRUARY 15, 1915.

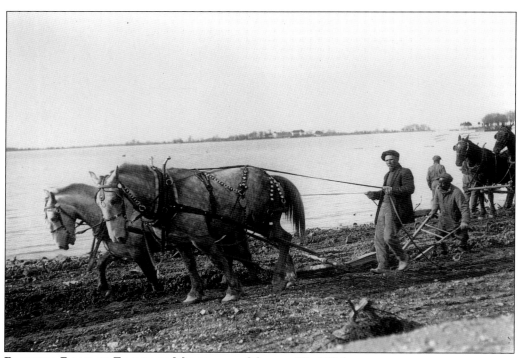

PLOWING ROAD IN FRONT OF MONUMENT, MARCH 27, 1915.

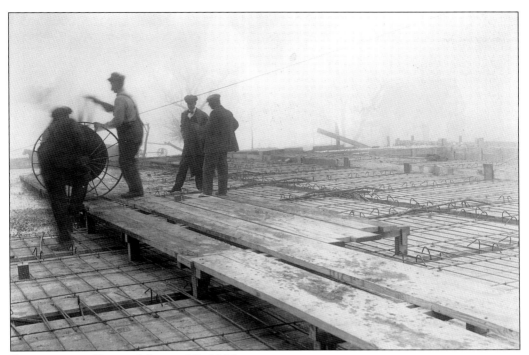

FORMS OF THE PLAZA, MARCH 15, 1915.

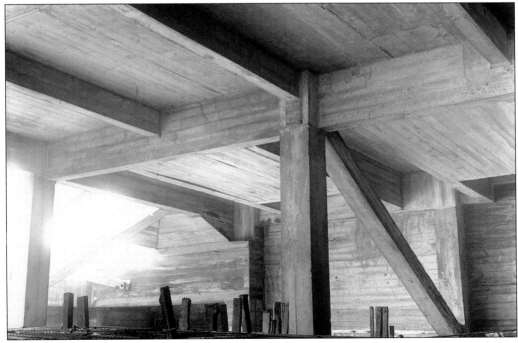

UNDERSIDE OF COMPLETED PLAZA, C. MARCH 1915.

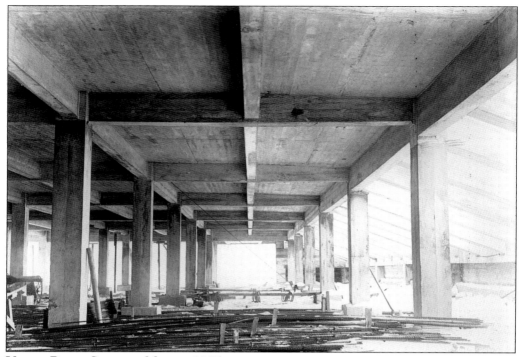

UNDER PLAZA STEPS, C. MARCH 1915.

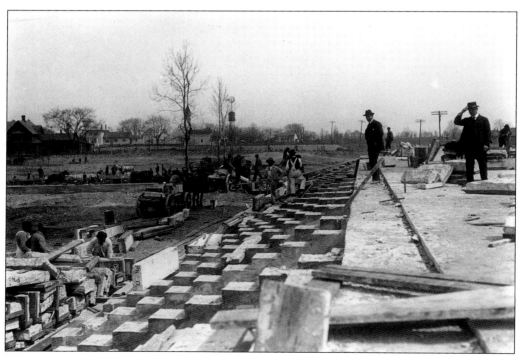

WORKING ON PLAZA STEPS, C. MARCH 1915.

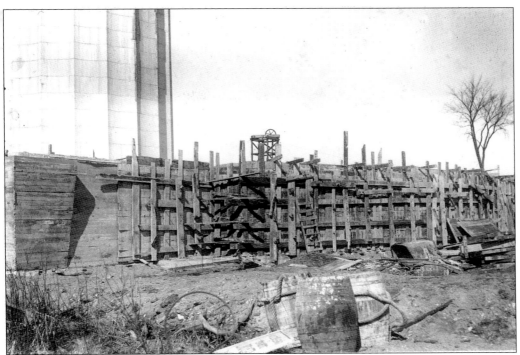

REAR OF PLAZA FORMS IN PLACE, C. MARCH 1915.

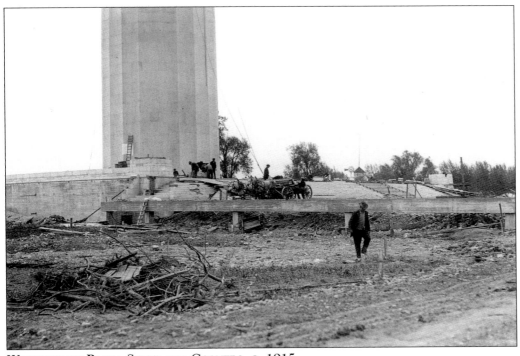

WORKING ON PLAZA STEPS AND CORNERS, C. 1915.

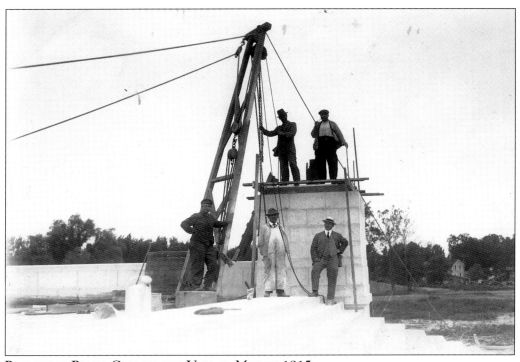

PREPARING PLAZA CORNER FOR URN, C. MARCH 1915.

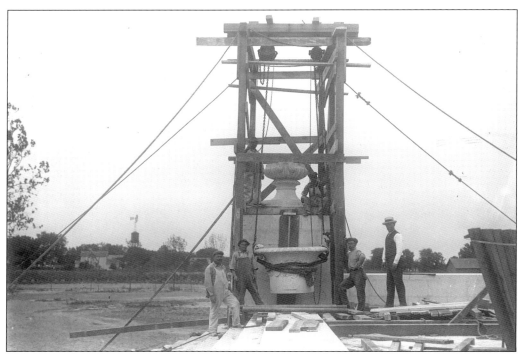

MOUNTING URN ON PLAZA, C. JUNE 1915.

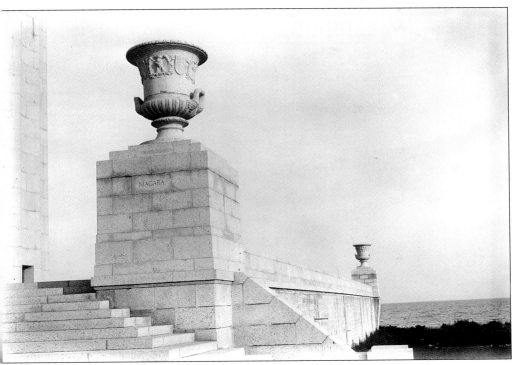

TWO URNS IN PLACE, C. MARCH 1915.

GRAVEL BED FOR SUPPORT OF PLAZA STONES, C. MARCH 1915.

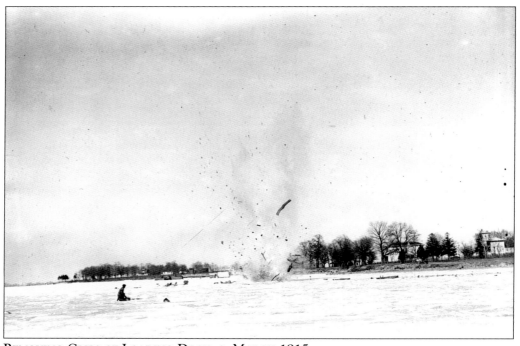

REMOVING CRIBS OF LOADING DOCK, C. MARCH 1915.

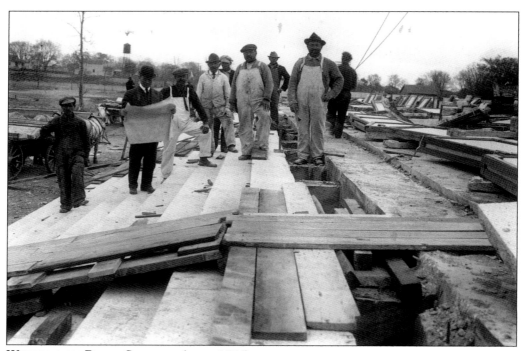

WORKERS ON PLAZA STEPS, C. APRIL 1915.

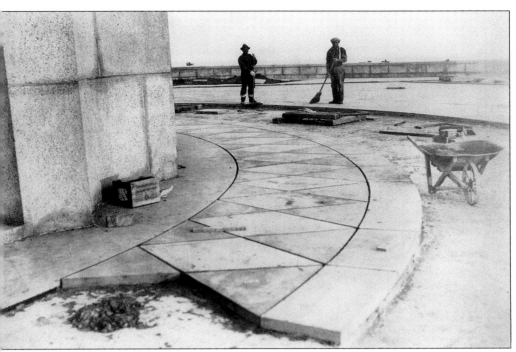

WORKERS SETTING TILES ON PLAZA, C. 1924–25.

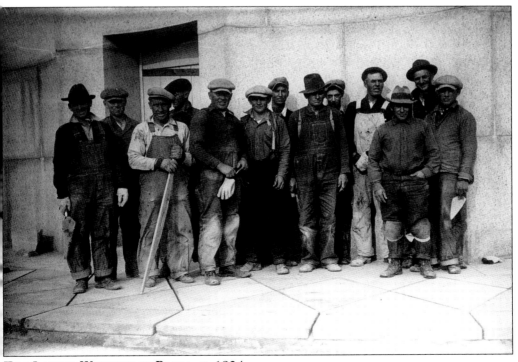

TILE LAYING WORKERS OF PLAZA, C. 1924.

MONUMENT OPENING

With the completion of the Stewart contract of the revamped plaza design, Perry's Victory and International Peace Memorial opened with no elaborate ceremony on June 13, 1915. A decade later, appropriated funds allowed improvements to landscaping and a new plaza surface.

Since its initial opening in 1915, much has been done to improve the surrounding landscape. In 1919, the Perry's Victory Centennial Commission received federal recognition by an act of Congress and became the Perry's Victory Memorial Commission, making it easier to obtain funds for improvements. That same year, additional funds permitted more improvements to the landscaping, including trees and additional turf.

In 1924, additional funding was used to improve landscaping, set sandstone tiles on the plazas, build a protective seawall along the lake shore, and install lightning arresters on the monument. By 1926, sandstone tiles also covered the lower plaza. The Milford Pink Granite tiles we see today came from the same quarry as the original pink granite, but were not placed on the plazas until the early 1980s. Floodlights added in 1928 illuminate the monument at night. On July 31, 1931, an official dedication took place celebrating the monument's completion. Five years later, Congress gave President Franklin D. Roosevelt authority to add the monument to the National Park Service, establishing it as Perry's Victory and International Peace Memorial National Monument in July 1936.

No new major construction occurred on the federal land until the 1980s, when new housing was constructed for both year-round and seasonal employees, and a modern building was completed to support maintenance of the buildings and grounds. Today, plans are underway for a Visitor Center befitting the magnificence of the monument.

CONCLUSION

Construction of the Perry's Victory and International Peace Memorial, considered an engineering marvel, deserved recording. Fortunately those responsible for its construction possessed the insight to create a pictorial record of the construction. This book utilizes this pictorial record as originally intended. These pictures give some insight to the work, craftsmanship, and challenge this structure presented to construction.

The monument of Perry's Victory and International Peace Memorial serves two purposes. Its original intent was a monument to honor Oliver Hazard Perry, the victorious commander of the U.S. fleet in the Battle of Lake Erie. With its addition to the National Park Service in 1936, the long lasting peace resulting from the War of 1812 became its primary significance. The extensive border between the United States and Canada, along with the peace shared with England, shines as an example of the ultimate goal of diplomacy.

The diplomats of these countries, who initially sat down to discuss and plan war against each other, had the insight and intelligence to later sit down and plan a lasting peace. This peace created the longest undefended border in the world between Canada and the United States and exemplifies what countries can do when committed to work together toward a common goal.

APPENDIX I

About the Photographer

G. Otto Herbster (1881–1968) was an established photographer at Put-in-Bay. A prominent island photographer, he was contracted by the Interstate Board of the Perry's Victory Commission to make a photographic record of the construction of the Perry's Victory and International Peace Memorial.

APPENDIX II

Facts and Specifications of Perry's Victory and International Peace Memorial

1. WORLD'S LARGEST GREEK DORIC COLUMN:

Height above lake level	352 feet (107 meters)
Height of parapet above lake level	317 feet (96 meters)
Height above Upper Plaza	340 feet (104 meters)
Height of parapet above Upper Plaza	305 feet (93 meters)
Size of parapet	47 feet 6 inch square (9 meters)
Column diameter at base	45 feet (14 meters)
Column diameter at top	35 feet 6 inches (11 meters)
Inside well of column	27 feet 6 inches (9 meters)
Wall thickness at base	9 feet 4 inches (3 meters)
Wall thickness at top	4 feet (1.3 meters)

124

Granite block size at base	5 tons
Granite block size at top	2 tons

2. CONSTRUCTED FROM OCTOBER, 1912 TO JUNE, 1915 (32 MONTHS)

3. ARCHITECTS: Joseph Freedlander and Alexander Seymour, Jr., New York, New York.

4. CONTRACTS: J.C. Robinson and Son Company, New York and Chicago-Memorial built by the Chicago office.
Stewart Engineering Corporation, New York-plaza construction.

5. MONUMENT WAS PAID FOR WITH DONATIONS FROM THE STATES OF OHIO, PENNSYLVANIA, MICHIGAN, WISCONSIN, ILLINOIS, NEW YORK, MASSACHUSETTS, RHODE ISLAND, KENTUCKY, AND THE FEDERAL GOVERNMENT.

6. COST TO BUILD:

Column Contract—1912	$357,588.00
Plaza (Gravel)—1914	$122,786.00
Landscaping—1919	$ 20,000.00
Plaza (Sandstone)—1924	$100,000.00
Lights—1928	$ 14,000.00
Plaza (Granite)—1982	$2,100,000.00
Total (Approximately)	$2,714,374.00

7. ESTIMATED WEIGHT OF COLUMN IS 18,400 TONS OR 36,800,000 POUNDS (16,692 METRIC TONS).

8. THERE ARE 78 COURSES OR LAYERS OF GRANITE, 30 BLOCKS OF THREE SHAPES MAKE ONE COURSE AND MAKE UP THE 20 FLUTES OF THE COLUMN. A TOTAL OF 2,340 BLOCKS MAKE UP THE COLUMN SHAFT. 3084 PIECES OF GRANITE MAKE UP THE COLUMN OVERALL.

9. STAIRS:

The hardened concrete staircase which surrounds the elevator shaft has	427 steps
Upper plaza to lower elevator landing	37 steps
Upper landing to Parapet	3 steps
Total from upper plaza to Observation Parapet	467 steps

10. BRONZE URN ON PINNACLE OF MEMORIAL:

Weight	11 tons (9,900 kg)
Height	22 feet, 10 inches (7m)
Diameter	17 feet 4 inches (5.5m)

11. THE FLOOR OF THE ROTUNDA CONSISTS OF TENNESSEE (WHITE) AND ITALIAN (BLACK) MARBLE. THE DOMED WALLS AND CEILING ARE COMPRISED OF INDIANA LIMESTONE.

GLOSSARY

[1] Cofferdam—A temporary watertight enclosure from which water is pumped to expose the bottom beneath a body of water and permit construction (as of foundations and piers).

[2] Ashlar—a squared building stone cut more or less true on all faces adjacent to those of other stones so as to permit very thin mortar joints.

[3] Batter—a receding upward slope of the outer face of a wall or other structure causing a decrease in thickness as it ascends.

[4] Header—A brick or stone laid in a wall so that its shorter ends are exposed to the surface.

[5] Stretcher—A stone or brick laid in a wall with its longer ends exposed to the surface. This case has the two masonry styles used alternately on each course.

[6] Entasis—a slight convexity as found beginning at the base of a shaft continuing to the top. It is greatest at a little below the middle point. Prevents the optical illusion of appearing thinner in the middle.

[7] Derrick—A crane consisting of a pivoting mast having a boom hinged at its base and carrying at its outer end a hoisting tackle. The outer end of this boom is also secured by a hoisting tackle to the head of the mast to permit raising and lowering of the end of the boom.

[8] Jackscrew—a jack for lifting consisting of a screw steadied by a threaded support and carrying a plate or other part bearing the load.

[9] Stringer—a longitudinal bridge girder for supporting part of a deck or track between bents (columns) or piers.

[10] Tread—the horizontal upper surface of a step in a stair, on which the foot is placed.

[11] Riser—the vertical face of a stair step.

[12] Echinus—The prominent circular molding supporting the abacus (see below) of a Doric column. A transitional section between vertical column and horizontal abacus at the top of a column which distributes the weight of the platform to a greater area than the column diameter.

[13] Cantilever—Any rigid construction extending horizontally beyond its vertical support in which no external bracing is used.

[14] Sinkage—a surface sunk for decorative effect.

[15] Necking—a molding or group of moldings between the projecting part of a capital of a column and the shaft.

[16] Fillets—a narrow flat molding or area, raised or sunk between larger moldings or areas.

[17] Cramp—a device, usually of iron bent at the ends or of dovetail form used to hold together blocks of stone or timber.

[18] Abacus—a horizontal slab forming the top of the capital of a column. feet. When the echinus was finished, work began on the cap of the column.

[19] Parapet—a low wall or similar barrier.

[20] Soffit—the underside of an overhanging member.

[21] Dovetail—a projection (tenon) broader at its end than at its base.

ENDNOTES

[22] Mongin, Alfred, A Construction History of Perry's Victory and International Peace
 Memorial, National Park Service, U.S. Department of the Interior, 1961, p. 35, vol I.

[23] Mongin, p. 156, vol II.

[24] Mongin, p. 218, vol II.

SOURCES CONSULTED

Baird, Howard C.(?), "Building a Granite Shaft 300 ft. High: The Perry Memorial" *Engineering News*, 72 #4 (23 July 1914): 172–176.

———, "Reinforced-Concrete Cap of Perry Memorial Column" *Engineering News*, 74 #4 (22 July 1915): 154–155.

Curran, Paul E., Correspondence from and conversation with this Milford Massachusetts historian. August 2–6, 1998.

Emerson, George D., *The Perry's Victory Centenary Report of the Perry's Victory Centennial Commission State of New York*, Albany, J.B. Lyon Company, 1916.

Herbster, G. Otto, " Photographic record collection of construction of the Perry Memorial." Herbster was a prominent island photographer that was contracted by the Interstate Board of the Perry's Victory Centennial Commission to make a photographic record of monument construction.

Mongin, Alfred, "*A Construction History of the Perry's Victory and International Peace Memorial*" August 10, 1961. Vol. I, II.

National Park Service, United States Department of the Interior.